CALDER'S CIRCUS

Edited by Jean Lipman
with Nancy Foote

Circus Figures Photographed by
Marvin Schwartz
Designed by
Ellen Hsiao

E. P. Dutton & Co., Inc. New York
in association with the Whitney Museum of American Art

First Edition

Published simultaneously in Canada
by Clarke, Irwin & Company Limited, Toronto and Vancouver.

Library of Congress Catalog Card Number: 72-075014

SBN 0-525-07305-1 (Cloth edition) SBN 0-525-47329-7 (Paper edition)

Grateful acknowledgment is made to the following for permission to
quote from copyright material:

Alexander Calder and Jean Davidson: *Calder: An Autobiography with
Pictures*. Excerpts and photographs reprinted by permission of
Pantheon Books, Inc., a Division of Random House, Inc., New York,
and by permission of Allen Lane, The Penguin Press, London.
Copyright © 1966 by Alexander Calder and Jean Davidson.

Cleve Gray: Excerpts from interview "Calder's
Circus," *Art in America,* No. 5, 1964. Reprinted by permission of
the author. Copyright © 1964 by Cleve Gray.

Photographs by Marvin Schwartz
Printed by Sydney Kaplan of Custom Dark Room
Type set by H.O. Bullard, New York
Black and white lithography and paper edition binding,
The Murray Printing Company, Forge Village, Massachusetts
Color lithography, The Lehigh Press, Pennsauken, New Jersey
Cloth edition binding, American Book-Stratford Press, Inc., New York
Designed by Ellen Hsiao

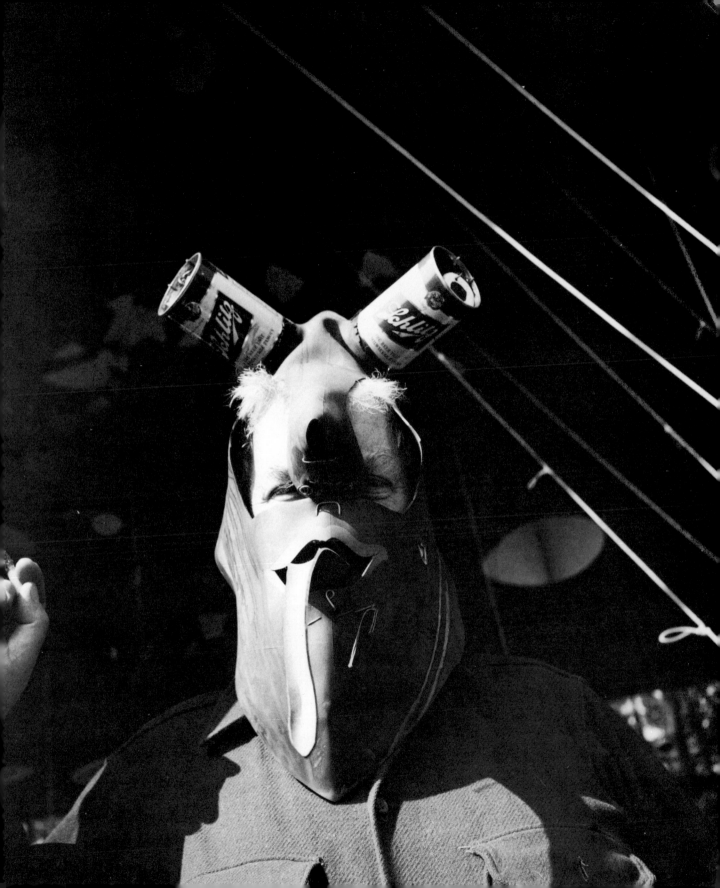

Introduction

Alexander Calder, creator of the mobile and the stabile, occupies a unique position as the sculptor who is generally considered America's greatest, and the American artist with the widest international reputation today. His fame, and his career as a sculptor, began almost fifty years ago with his miniature Circus.

The Circus, now on extended loan to the Whitney Museum of American Art in New York and on permanent display there, was begun in the mid-twenties with just a few figures. Calder enlarged the Circus over half a dozen years into a full performance with a troupe of dozens of people and animals. He was invited in the twenties, thirties, forties, and fifties to give shows for special audiences in America and abroad; the press clippings, expressing enthusiasm in many languages, occupy an astonishing number of pages in Calder's scrapbook. During the early years of this century artists were interested in the circus as a popular art, and Calder's performance attracted them. His Circus brought him into early contact with the leaders of the Paris art world—Mondrian, Miró, Cocteau, Kiesler, Man Ray, Pascin, Léger, Foujita, Pevsner, Arp—many of whom inspired various aspects of his style. It is most significant, however, as a laboratory in which all the most original features of his later work developed. (James Johnson Sweeney pointed this out many years ago in his catalogue [1943] for a major retrospective of Calder's work at the Museum of Modern Art in New York.)

The toys, wire, wood and bronze sculpture, jewelry, drawings, gouaches, and even the great mobiles and stabiles and the recent "animobiles" evolved from the miniature Circus. Calder's constant partiality for animal sculpture and his use of specific circus subjects and titles are significant, but less so than the fact that the basic qualities of his major works have developed as abstractions of his early Circus troupe. This is especially evident in the mobiles, with their precision engineering, their tightrope tension and balance, and their lively acrobatic motion. The circus aesthetic—a combination of suspense, surprise, spontaneity, humor, gaiety, playfulness—has always been the basis of Calder's work. It's interesting that in 1967 he named a monumental stabile after the Circus ringmaster, Monsieur Loyal, but more so that a recent book on Calder juxtaposes photographs of actual circus tightrope acts with mobiles, and performing circus elephants with large stabiles.

This book presents the Circus and examples of the many circus sculptures in wire, wood, and bronze, as well as the circus paintings, drawings, and gouaches, and various other sculptures that relate to Calder's longtime interest in the circus. It is divided into three parts: the Circus years; color stills from the Pathé film of a Circus performance; and the Circus figures themselves, photographed by Marvin Schwartz and shown with related pieces in all the media that Calder has used. The occasional quotations that accompany the illustrations—Calder's remarks about circus things—are the only "text" in the book. An appendix includes a chronology of events in Calder's career that relate to the Circus, detailed captions for each illustration, and an annotated bibliography.

I went to the circus, Ringling Brothers and Barnum & Bailey. I spent two full weeks there practically every day and night. I could tell by the music what act was getting on and used to rush to some vantage point. Some acts were better seen from above and others from below. At the end of these two weeks, I took a half-page layout to the *Police Gazette* and Robinson said, "We can't do anything with these people, the bastards never send us any tickets."

I always loved the circus—I used to go in New York when I worked on the *Police Gazette.* I got a pass and went every day for two weeks, so I decided to make a circus just for the fun of it.

Circus sketches, *National Police Gazette,* 1925

SEEING THE CIRCUS WITH "SANDY" CALDER

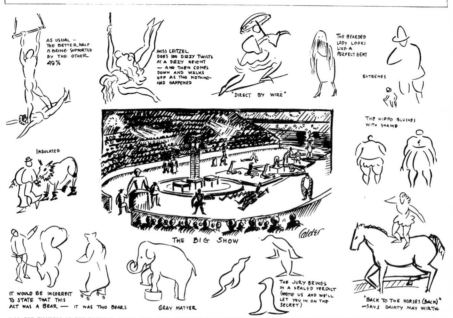

ALL THE WONDERS OF THE WORLD IN THREE RINGS—SOME IMPRESSIONISTIC SKETCHES OF THE BARNUM-RINGLING CIRCUS WHILE IT WAS SHOWING IN NEW YORK. Recently, in Madison Square Garden, Just Prior to the Demolition of that Historic Amphitheatre. The "Big Show" Is the Best Sort of Spring Tonic for the Grown-ups As Well As the Youngsters. It Preserves Some of the Romance of Youth that the Rush and Bustle of City Life 'o Soon Impair or Destroy. Calder Shows Us Not Only the Main Show, but the Freaks of the Side-show.

BOXING AND WRESTLING NEWS THE WORLD OVER FEATURED IN EVERY ISSUE OF THE POLICE GAZETTE

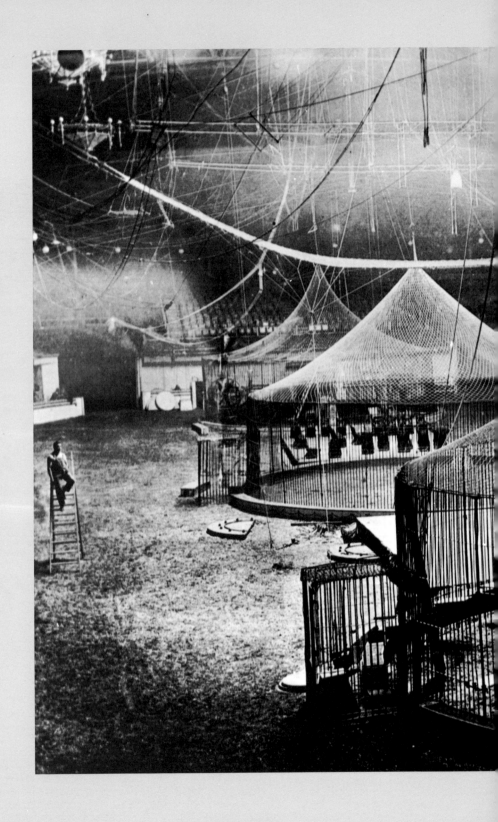

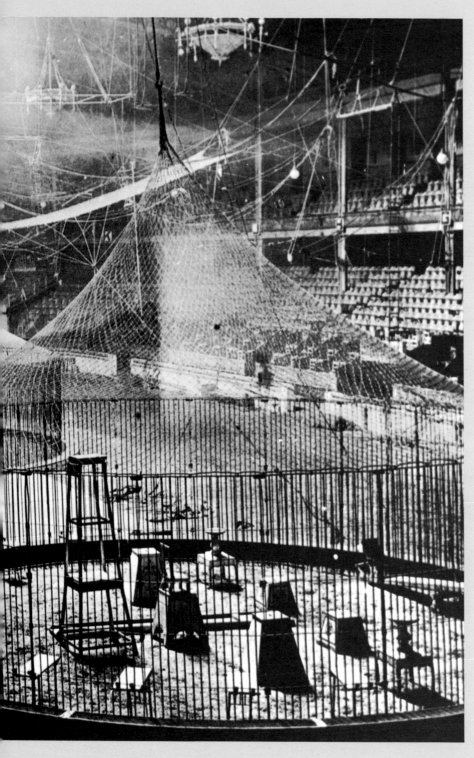

The circus as Calder saw it
in the 20s
see next two pages also

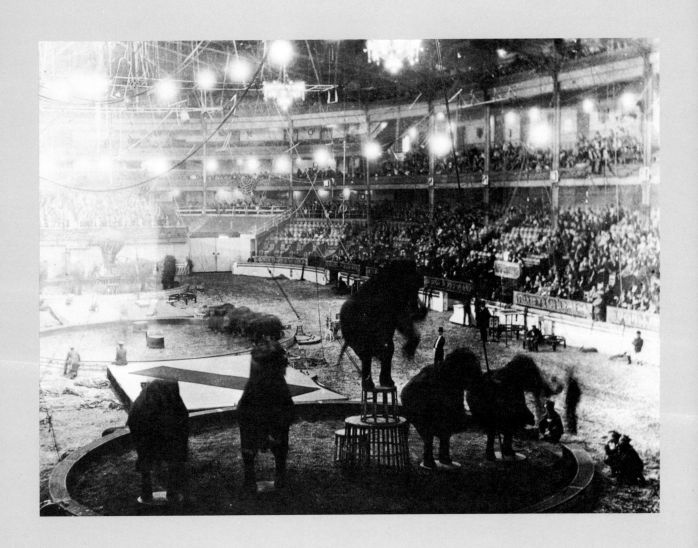

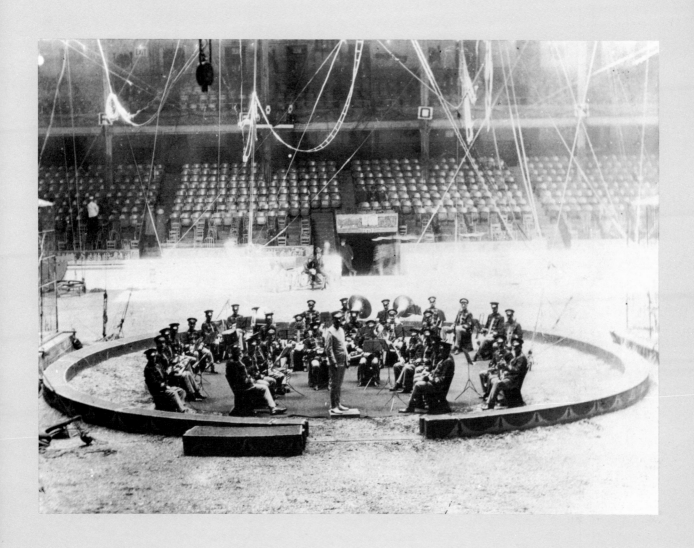

I started the circus for myself. An American woman, Frances Robbins, saw it, then she sent an English woman, Mary Butts, who sent Cocteau. He was excited. He started making masks out of pipe cleaners, but they were sort of soft.

Before my return to New York, in the early fall of 1927, I wanted to take my circus with me, and I had to submit the two suitcases which held the show then—it has grown to five since—to the Douane Centrale in Paris. All the artists were stamped with a rubber stamp on the buttocks. Some still carry traces of this branding.

In the spring of 1929, a photographer named Sacha Stone came to the rue Cels to see my circus. He lived in Berlin and proposed that I go there.

Somebody from Baltimore butted into my business and arranged a show in Eddie Warburg's gallery at Harvard. Warburg and Kirstein had hired a floor in an office building across the street from the college. I repeated my bundle of Berlin days, but Eddie protested that I arrived with nothing but a roll of wire on my shoulders and pliers in my pocket. I admit there was some truth to this, for I always traveled with a roll of wire and a pair of pliers. I took the circus along too, and showed it to the Harvard boys.

Louisa arrived at about the time Fredric Kiesler—a Viennese architect who had done a few things in Paris and then gone on to New York—was having a fling with my circus. From previous years, Kiesler knew Fernand Léger, Karl Einstein, the critic, Le Corbusier, Mondrian, and van Doesburg. He gave me a list of whom to invite for the circus, so I invited them all for the same night, at the Villa Brune. Another Einstein—from St. Louis, this one—was to be my *chef d'orchestre.*
 I saw Kiesler before the performance, and there was great consternation in his camp because I had invited van Doesburg with the others. He apparently was a friend of Mondrian but on cool terms with Karl Einstein and maybe Léger.
 That was Paris, and I never understood the battles of these coteries—and somehow or other I remained aloof from all this.
 But Kiesler insisted we must head off van Doesburg at all cost, so we finally sent him a telegram, explaining that there was some error and that he could come the following day.
 Kiesler and his gang came to the circus, and this time I do not remember any reaction. However, Léger was interested in what I did and we became very good friends.
 The following day, van Doesburg came with his wife Petro, of whom Louisa and I later became very fond. They also brought their two little dogs —they would rush and yap at every shot of a pistol or crash of cymbals. But I got more of a reaction from Doesburg than I had from the whole gang the night before.

The St. Louis Einstein had a smattering of knowledge on all these people which he had picked up from books. The next day, he called on Mondrian by himself. He came back to Villa Brune and recounted marvels, so I went with him to see Mondrian.

I was making the most of the studio being so close to our living quarters, working for hours every day, but feeling free to knock off if something worth while came along. Once in a while I would pull the workbenches around, link them with planks, make the bleachers for the circus, and we would have it three nights running. Sometimes, we had nearly a hundred people. There were regular aficionados and occasionally some new people; others were bringing someone along. In the front row, there was always a place reserved for Louisa's great-aunt, Mrs. Alice Cuyler, who was quite elderly but enthusiastic.

The Nelsons in Varengeville expected a gay Calder. I arrived with a rather drawn visage and they wondered what was the matter. We were the last off the boat, due to the volume of our luggage.
 The *douanier* said:
 "Where do your things end? There?"
 And I said:
 "No, over there."
 "There?" he said then, pointing further.
 And I said:
 "No, over there."
 The first thing he opened was one of the valises of the circus, and he said:
 "Ca, c'est du cirque."
 He passed everything.

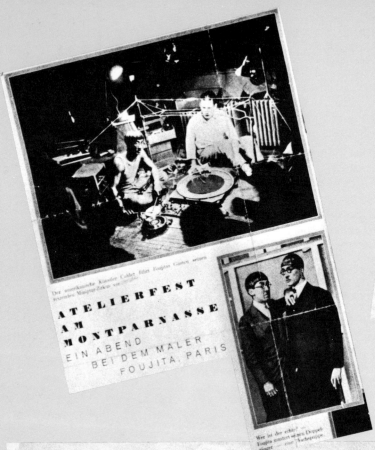

Der amerikanische Künstler Calder führt Foujitas Garten seines relativistan Mininur-Zirkus vor

**ATELIERFEST
AM
MONTPARNASSE**

EIN ABEND
BEI DEM MALER
FOUJITA, PARIS

Wer ist der echte? Foujita montiert seinen Doppelgänger — zur Nachprüfung.

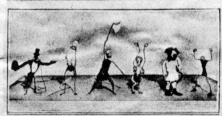

La Volonté
19 Mai 1929

théâtrale

Alexandre Calder
et son cirque automate

The World

METROPOLITAN SECTION

NEW YORK, SUNDAY, JANUARY 18, 1931

His Elephants Don't Drink

Sandy Calder, Snubbing Riches in Cow Factory, Puts on His Own Circus

By Hickman Powell

PRESENTING, ladies and gentlemen, the most stupendously haywire show on earth!

Calder's Circus, fresh from triumphs in the artist quarters of Berlin and Paris and fresher from an unprecedented run of five nights on Broadway. And Sandy Calder himself, down on his hands and knees in a corner of the eleven-foot-square vacant store he hired at 905 Seventh Avenue, just up from 57th Street, furiously shaking the champagne-cork head of a wire steer at the rubber-armed cowboy roping him; daintily jumping the bareback rider over a rope at the behest of an egg-beater's machinery.

And a capacity audience of thirty persons, more or less on the artistic side, half of them down on their hands and knees too, catching breath at the suspense of the moment that little wire-limbed tinsel lady on the swinging trapeze, will dive at the mere behest of pulling strings, turn a death-defying double somersault in midair and catch the other trapeze! A nosing cheer and a burst of cymbals as she rises at its limit; a shout of laughter as a pair of flicker-footed stretcher bearers rush out to collect her shattered bones, which have missed the safety net.

Here, ladies and gentlemen, is Barnum's complete, in a round three shows acts, from the galumphing elephant (who spouts sawdust from a lively swaying chorus race)...

And here, solemnly handing the graceful tightwire lady, making her jump over a tank...

...who handles the imaginative dimensions of the classic...

Alexander Calder, may it here be said, is a young sculptor who has already attained the solid status in the Atlantic salons of those who count as a first-rate creative talent...

...you are one of those who take in the author of these wood carvings at the correct show of humor... the Museum of Modern Art particularly that nine woman head double, and particularly that page number, or perhaps you remember that page in Vanity Fair last year; photographs of his humorous sculptures in wire. You it is his show to see plays instead of chisel, and this circle is the side show of it.

Calder is a pure-bred Vermont Yankee with all his traditional inventiveness. Frugality, too, these circus performers and managers are made from ordinary bits of wire, rough bits of rags and cardboard, ordinary artist clothes pins, wine glass corks, bottle tops. What other person found cleaning around one house? And no attempt is made to polish these things off and perfect them. It's a bit more fun if you don't then remove! How pretty and tidy if you don't. Quite a show whether the complicated machinery is going to work. And in any case, you get the idea, as with Rube Goldberg.

And take it from these three circus enthusiasts, or fake it from me, that, except as it intends to be, this crackpot cuckoo circus is no laughing matter. Or better, take it from the illustrator, Alexander King (who being the music for the evening has just turned off the twittering bird music that accompanies the living-statuary of "Dawn and Dusk" and clanged the gong for the chariot race), that in these sketchy figures is the essence of what modern art is about, architectural abstractions aside. For here, by economical suggestion, is that intensified distillate of reality, the projection of keen observation, move real than reality itself. No attempt at photographic replica, caricature, if you will. That bit of brown velvet and lop-sided wheels, careening how and stern, is it not more bearlike than any zoo bruin you ever saw?

And don't, among the academic snob patronizing discussions about "artists" sculpture. What, by the way, were the names of those stiff-shirt academicians who patted Mark Twain on the head? But, remembering what the art critics did to Charlie Chaplin, let's not be pedantic, either.

Some years ago, the story goes, Calder carved a wooden cow. A dealer bought it.

"Calder, my boy," he said, "you've found your fork. You're a cowman. Make a lot of cows and we'll sell 'em and make a lot of money."

"Shucks," said Calder. "That piece of wood turned out to be a cow, but the next one might be a cat. How do I know?" And he took the next rattle boat for France, with a pair of pliers...

In his pocket and a sharp lookout for likely bits of wire.

In Paris he ran into a Serbian fellow who told him he could make money building toys. That was an idea. He had played with a humpty-dumpty circus, tore up to make something less literal and more real. Pretty soon ideas for toys were popping into his head so fast that the Paris fanicals were nearly running him down in the street. It would be easy enough to make any one mechanically perfect, but it was a lot more fun to make new toys. Calder had graduated in engineering; he had worked six months for (of all things!) the New York Edison Company. But you never can tell when education is going to come in handy. Shanks and stresses and a knowledge of wire were coming in handy now. Pretty soon Calder had a whole circus. Artists in Paris and Berlin and circus people too were applauding it. Calder made a necktie out of the same red and white striped stuff as the little tent he hoisted around his performing ring.

After European triumphs the circus came to this country to get married. And nothing could be but that it must have its chance, at least on the outskirts of Broadway. So it had its five-night run. It's up in Boston this week-end getting married and probably pursuing the Brahmans a bit. For all I know it may be back honeymooning in Seventh Avenue this week.

But on with the show. A penny whistle stops...

the blast of Barnum & Bailey music from the victrola. Calder blows a solemn blast on a nickel trumpet. The little ringmaster is set forward, lifting his large, white hand and megaphone.

"Mesdames et messieurs, je 'vous présente"—this circus was born in Paris—"Don Rodrigues Kolpy-y-ynoo!"

The little spotlight is turned toward the ceiling. And down, a steep, tight string from the ceiling, erect upon his feet, slides the Don himself, a death-defying feat. Crash the cymbals!

A curtain swings aside. The victrola is Oriental. On top of a cigar box a little lady of pink stocking with wiggly wires inside her, hitching to an egg-beater, enters the dance. Whenever here you seen a hootch so triumphantly lascivious!

Now the Sultan of Senegambia, flinging knives, torch-burning knives, at a tremulous, jelly-breasted lady. Viciously the spears pierce a cardboard backdrop. Now the sword swallower straightens his crooked stomach. The lion tamer puts his head in a yawny mouth. And Leo dramatically keels over dead at the detonation of a cap. A clown looks a horn and explodes a balloon.

But you get the idea and the pictures tell the rest. And Alex King is now passing around the hat. For the circus must somehow get back to France. And not by starting a mass production cow factory either.

Members of Alexander Calder's One-Man Circus — World-Wide Photo

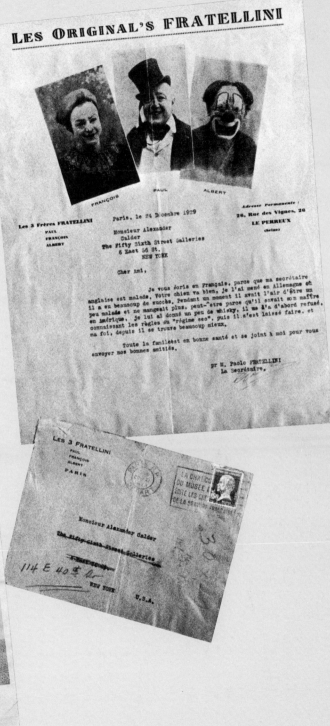

LE PLUS PETIT CIRQUE DU MONDE
pourrait tenir dans un carton à chapeau

Œuvre de patience du sculpteur Alex Calder, il donne pourtant, dans le privé, des représentations parfaites

On a remarqué le chien extraordinaire et synthétique qu'Alberto Fratellini tire par sa laisse à son entrée en piste, mais sait-on que cet hilarant animal est l'œuvre d'un fervent du cirque, créateur d'un cirque miniature : Alex Calder.

Alex Calder est le fils du grand sculpteur américain Calder; très jeune, il dut se familiariser avec les travaux de son père, mais ses goûts instinctifs le portèrent vers des inventions plus particulières, tel ce grand dessinateur japonais qui s'appelait lui-même « le fou du des-

Et c'est merveille !

L'an dernier, Alex Calder avait présenté son cirque minuscule chez Foujita très enthousiaste. On admira l'adresse du sauteur au tremplin, la pièce du trapéziste...

Pour la seconde fois, dans un appartement de la villa Brune, Alex Calder vient de présenter à nouveau son travail amélioré, complété avec amour.

Les critiques du cirque étaient présents et l'on pouvait voir MM. Fréjaville, Le

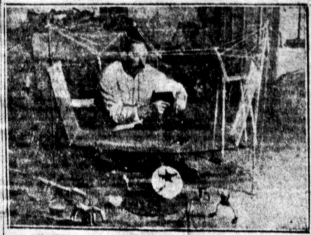

M. Alex Calder avec sa batoude et ses acrobates en miniature
(Photo Cami Stone)

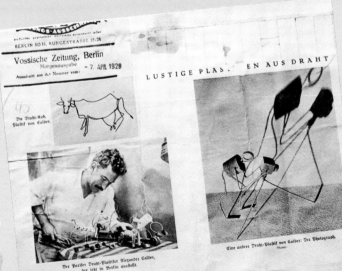

BERLIN SO 16, RUNGESTRASSE 27-24

Vossische Zeitung, Berlin
Morgenausgabe — 7. APR. 1928
Ausschnitt aus der Nummer vom:

LUSTIGE PLASTIKEN AUS DRAHT

Die Draht-Kuh. Plastik von Calder.

Der Pariser Draht-Plastiker Alexander Calder, der jetzt in Berlin ausstellt.

Eine andere Draht-Plastik von Calder: Der Photograph.

Clippings from Calder's scrapbook

Josephy was very enthusiastic over my circus. This encouraged me and while at his house, I worked on it very hard. He helped me. We made the chariot race and the lion tamer, and it got to be quite a full-blown circus, growing from two suitcases into five.

All this while, I was quite unaware of the financial straits of the world, even of the stock-market crash.

While still in Paris the previous spring, I had met Miss Mildred Harbeck, who had asked me to design some textiles. To convince her of my worth, I had at that time showed her some of the circus. Arriving in New York, I had done the textiles, and we decided to give a circus party in the house where she and her sister lived on Lexington Avenue. I think we invited Frank Crowninshield, *Vanity Fair* art editor, Edward Steichen, the photographer, and Mr. Erhard Weyhe, at whose gallery I had shown in New York. There were also many other guests.

The next morning, I guess I delivered something to the Weyhe Gallery, and I saw him and asked:

"Well, Mr. Weyhe, how did you like my circus last night?"

And he, with a slight German accent, replied:

"Mr. Kalder, yesterday I lost eight thousand dollahr . . ."

This did not depress me and I went back to work with Josephy, improving my circus.

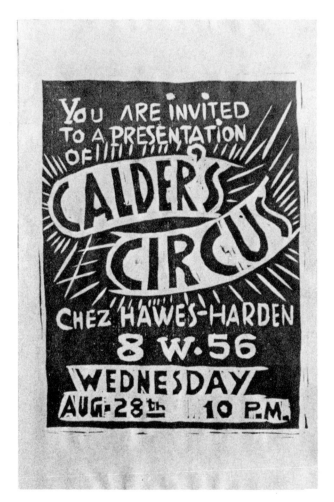
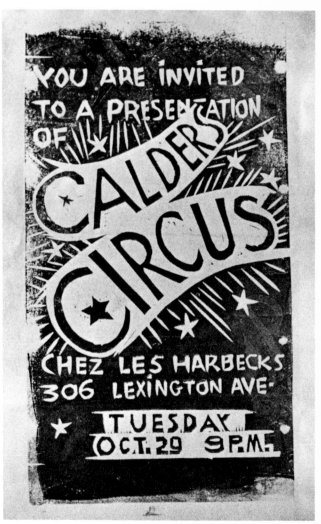

Invitations to Circus performances, 1929

Mrs. Aline Bernstein said that if she got a job she was hoping for, in theatrical production, she would buy this object and would I please call her up on a given day. I called her up and she did not have the job. I said, "I would like to invite you to my circus, but I don't know just where I am going to run it."

She said, "You can run it here, very soon—it is often a circus here, anyhow—and by the way, we are having a party this evening, why don't you join us?"

So, Louisa and I went. There were lots of people and lots of fancy food and liquor. The sky was the limit.

In those days, for the circus, I always had printed invitations, which I did myself with a linoleum cut. I wish I had some of these left. Mrs. Aline Bernstein set the date and asked me to invite some of my friends—she would invite some of hers. So I promptly sent her a batch of invitations, which were green and white, and she must have remembered that I had a few friends too.

The evening set, I arrived with my five valises and a very small gramophone. One entered on Park Avenue, but the place was really—at the end of a long corridor—on Madison. I was greeted by Mrs. Bernstein. There seemed to be four or five people around. The room was somewhat oblong. I pushed sofas back against the wall, then I removed a bust from a table behind me at a far corner. I recognized the bust as Noguchi's. The bust lady wore a monocle—she was the daughter of the house.

My hostess said, "That's a young Japanese sculptor." I said, "Yes, he's coming tonight." (I'd asked him to come and run the victrola for me.)

Her guests seemed to be dressed negligently or in negligees. My guests arrived and occupied the shorter of the two bleachers. They included Louisa, Bob and Jane Josephy, Millie and Sandy Knox, Val Dudensing and his wife, and Lee Simonson and others.

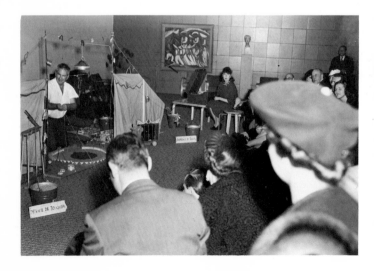

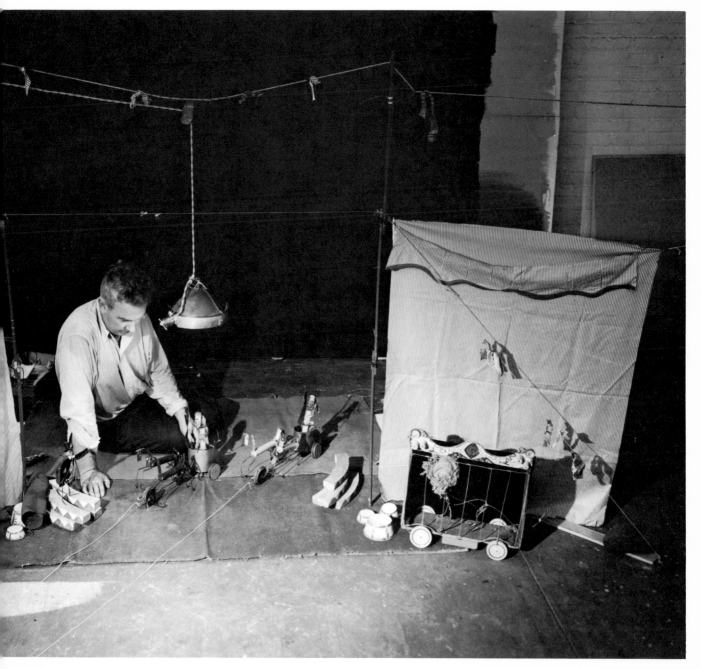

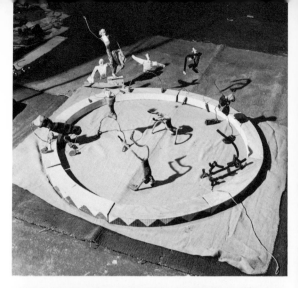

Millie Knox had a white fur coat, and Mrs. Bernstein's sister, who was in the clothing business, kept eyeing this coat —with I don't know what.

By and by Noguchi arrived and I had set up the masts, the various cords, and the curtains. As I spent most of the time on my knees when performing the circus, I had bought a pair of basketball kneepads and was trying to break these in.

Well, I performed the circus.

I remember Lee Simonson, who was right in front of me, being very careful to pick up his peanut shells and put them in a container to spare the "lovely" blond wall-to-wall carpet.

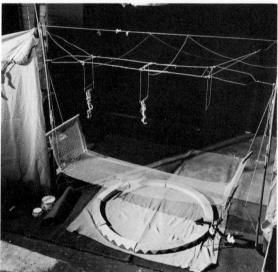

Finally the chariot race, the last act, came off and my friends went home. It was always a long job packing things afterward—like in the real circus—and I always did it myself, having the knack and the memory.

Mrs. Bernstein said, "It's a lot of work."

That was her only comment.

As I was packing up, I revealed a Bergdorf Goodman suit box—purple figures walking across a white field. Mrs. Bernstein's sister (who worked for Bergdorf Goodman) asked me, "Where did you get that box?"

It was her only comment.

I told her that Josephy, the friend with whom I was staying, had received it from his bootlegger with a load of liquor.

I was never aware that the great Wolfe—that is, Thomas Wolfe, the writer—was present at my circus performance. He did not have the good sense to present himself and I only heard from him much later—some nasty remarks on my performance, included in a long-winded book.

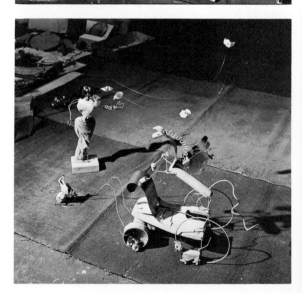

Circus performance, 1929

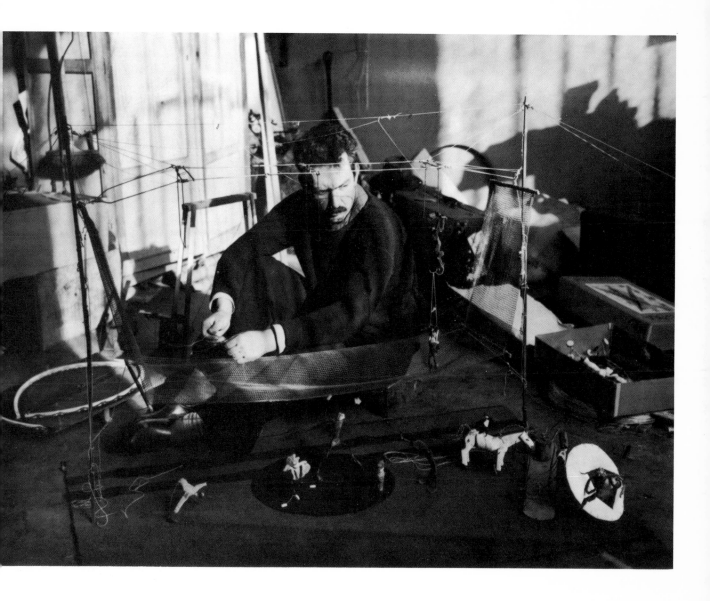

Paul Nitze asked me to present the circus to a few friends. I was a little late in setting things up and to get the right tension in the tightrope, I had to put two brads in the floor.

There was a chilly moment, and then the circus went on.

Finally, Louisa and I got married on the seventeenth of January, 1931. I took the circus to the James house in Concord, Massachusetts, and ran it the night before the wedding.

The reverend who married us apologized for having missed the circus the night before. So I said:

"But you are here for the circus, today."

I had brought my circus as usual and I borrowed a little store from a friend on Fifty-seventh Street and Seventh Avenue. I wanted to sell tickets for my show, but after investigation showed there was only one toilet and as the door did not open outward, I was not allowed a theatrical license. So we passed the hat—a rather doubtful procedure.

About the same time, the group Abstraction-Création had a show, Porte de Versailles, and I exhibited there too.

I also took the circus there and gave a performance for them, but it was raining outside and the drum got moist. The place was sort of a large tent, the sounds got lost, and it turned out to be rather lugubrious—my circus needs good acoustics and not too vast a space.

I had taken my circus along to Chicago, and gave several performances, and I think one evening I hired out to a Mrs. Brewster. She had an elegant black-and-white marble floor into which I could not nail. So we got a storm door and nailed a stick onto it at each corner to moor my guy lines. To add strength to the sticks, we piled a few logs of firewood on each. Mrs. Brewster, who had rented me out for fifty dollars instead of the hundred I asked, thought that this firewood was rather shabby, so she had some cyclamens brought in to stand in front of it.

I got rid of these.

Stills from the film *Calder's Little Circus*, 1961

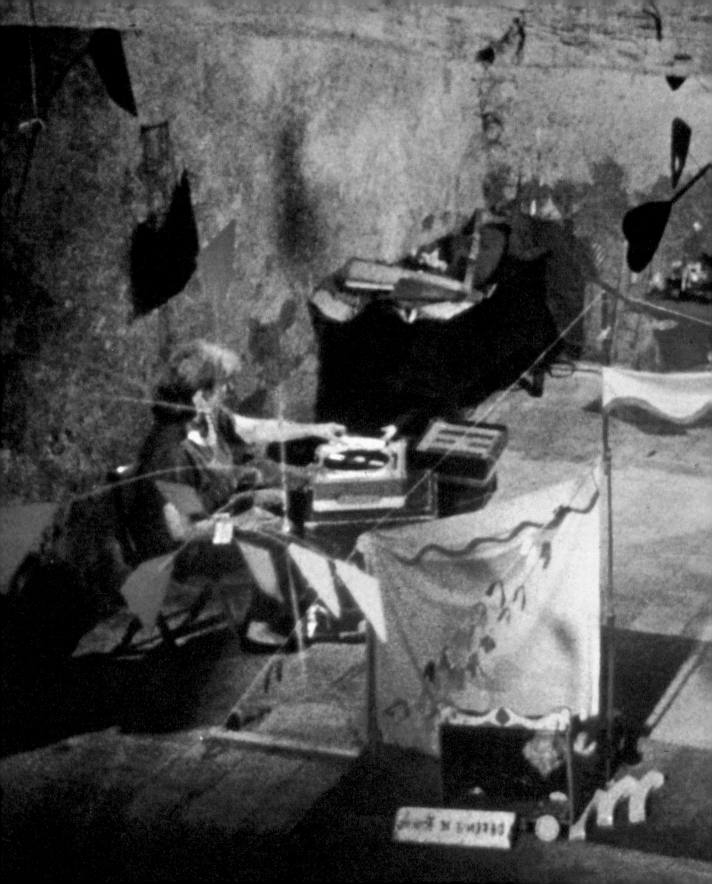

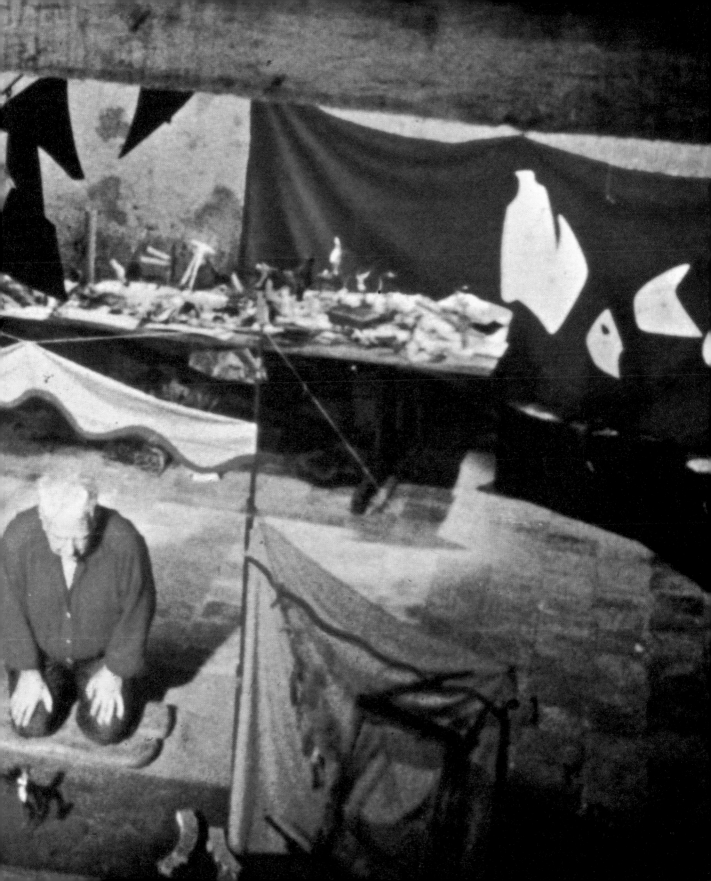

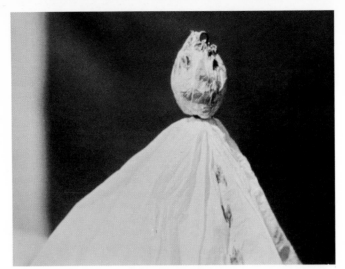

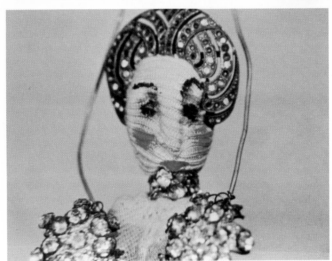

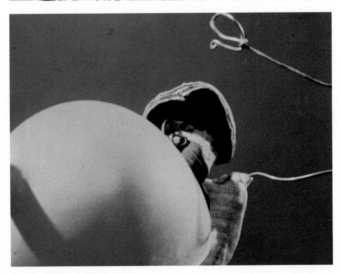

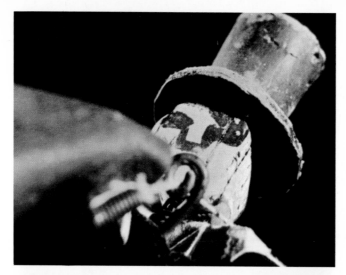

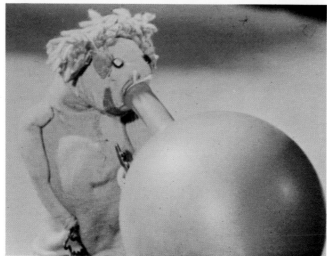

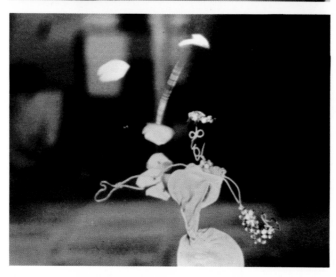

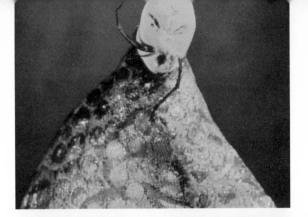

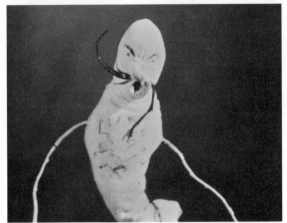

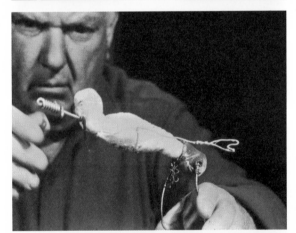

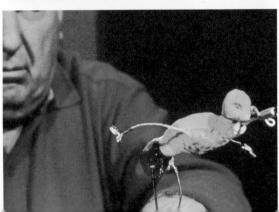

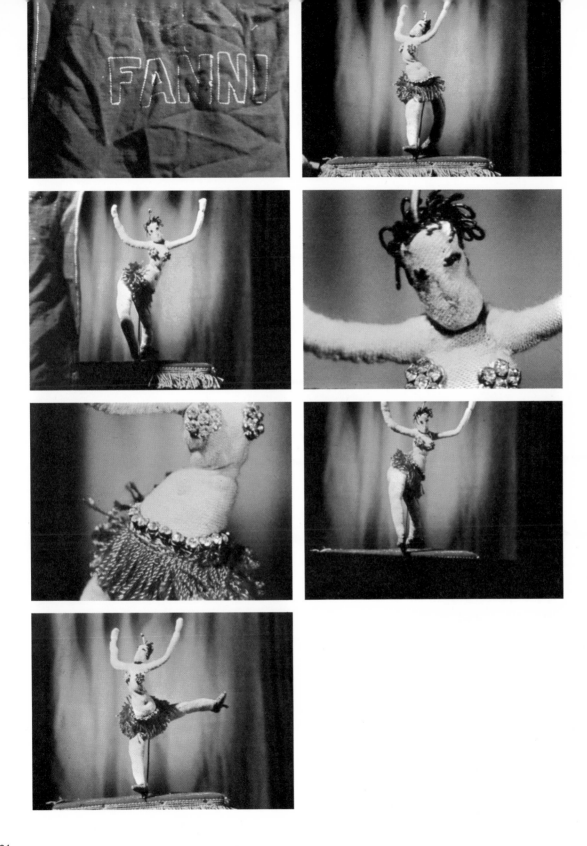

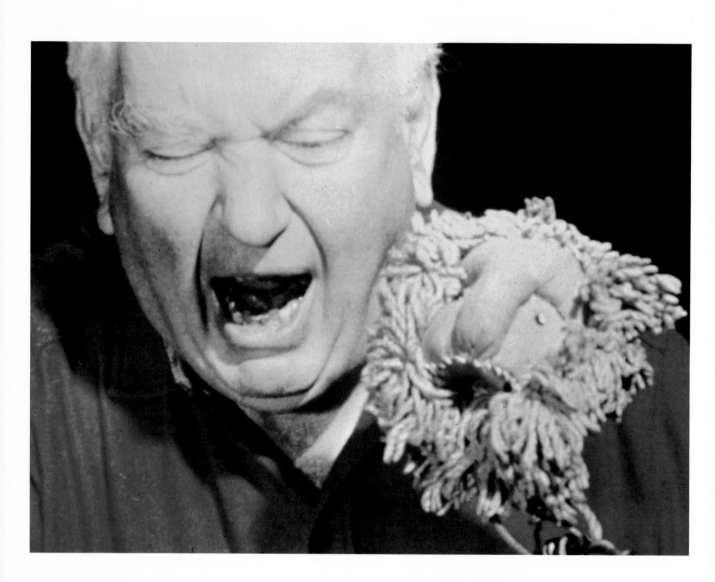

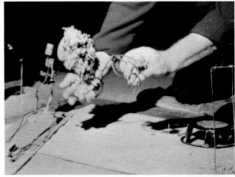

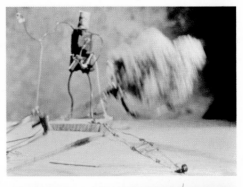

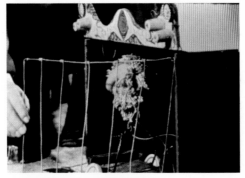

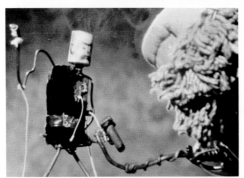

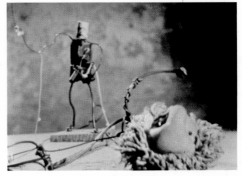

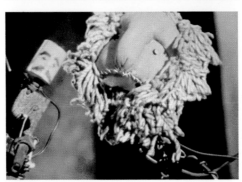

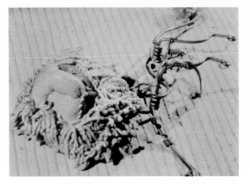

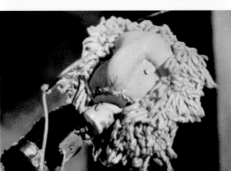

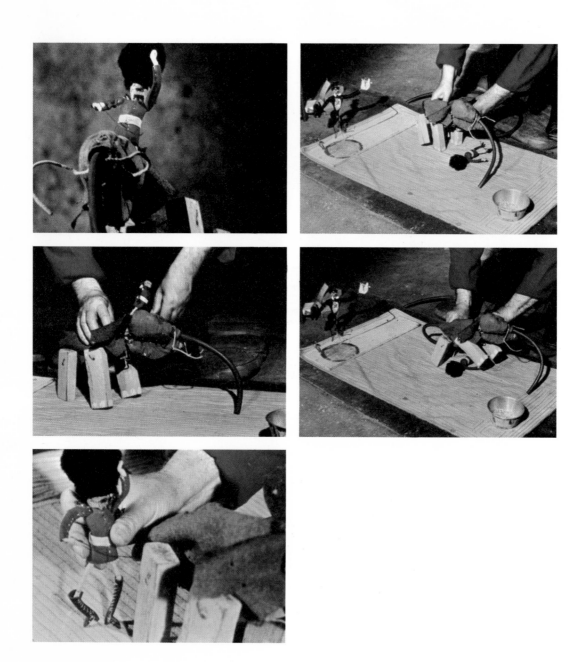

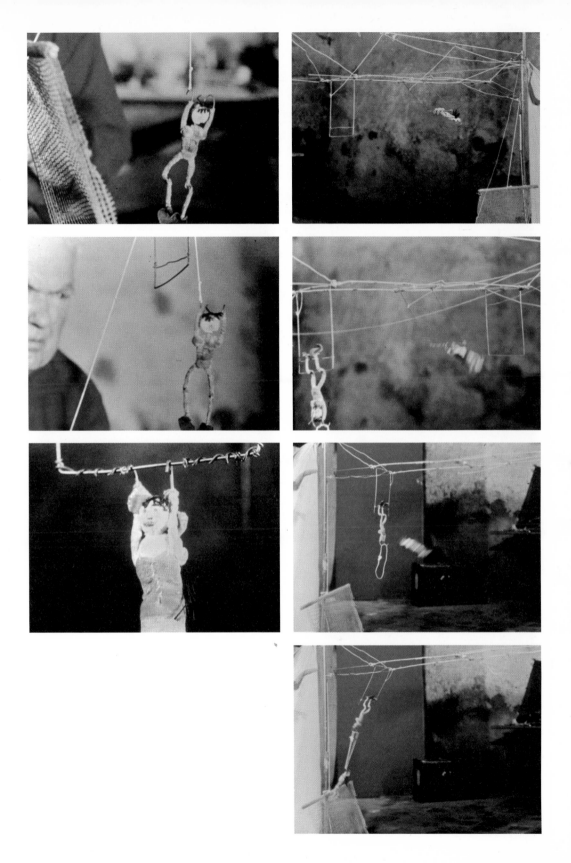

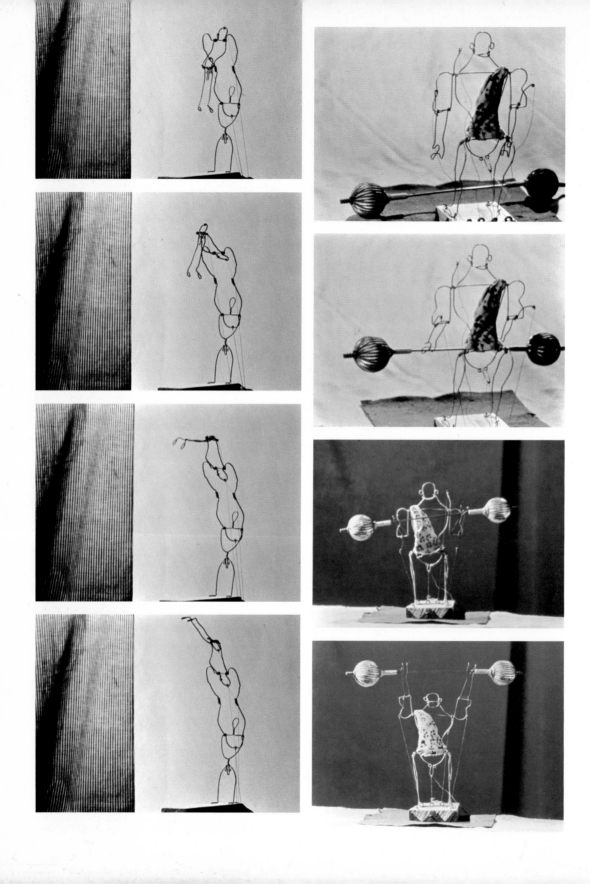

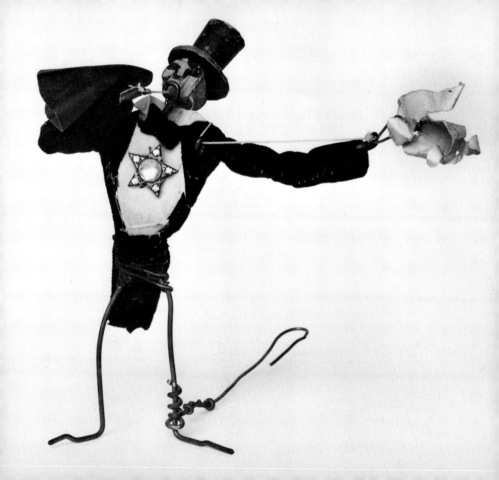

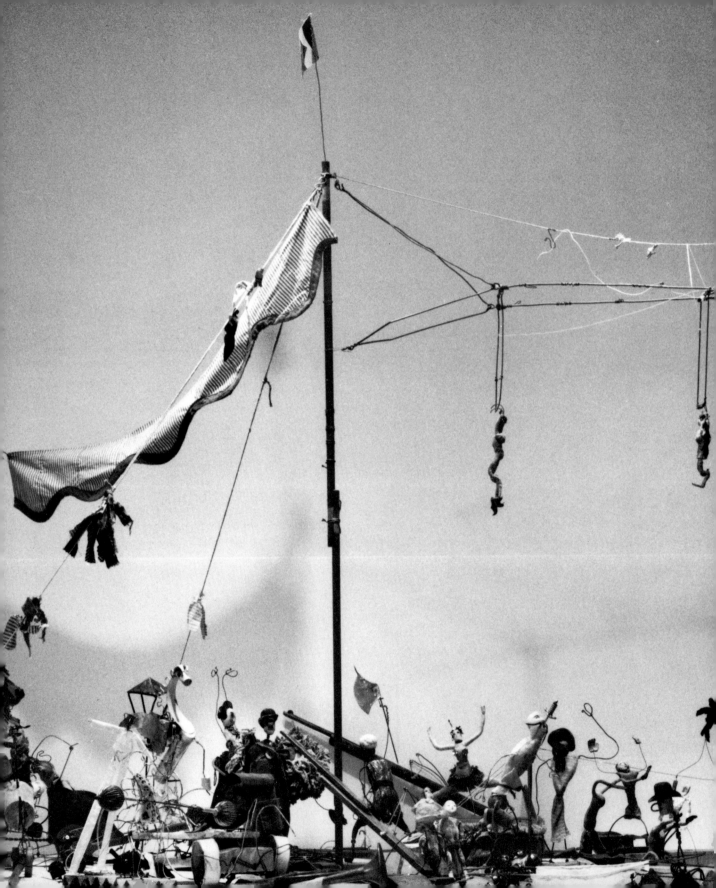

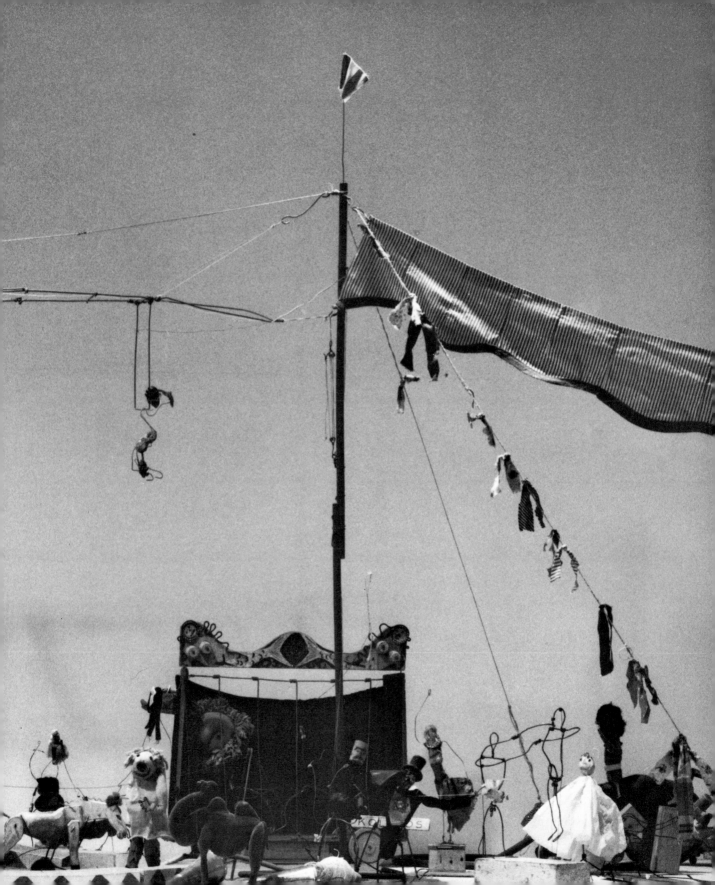

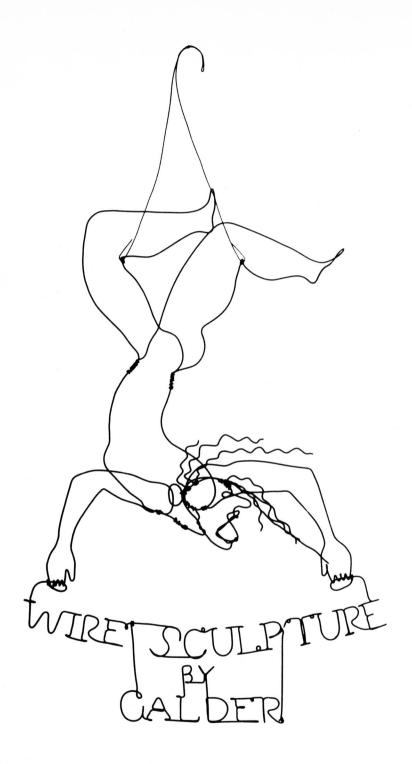

left
Sign for Weyhe Gallery exhibition, 1928
above
Lettering for magazine article, 1964

I've always been delighted by the way things are hooked together. It's just like a diagram of force. I love the mechanics of the thing—and the vast space—and the spotlight.

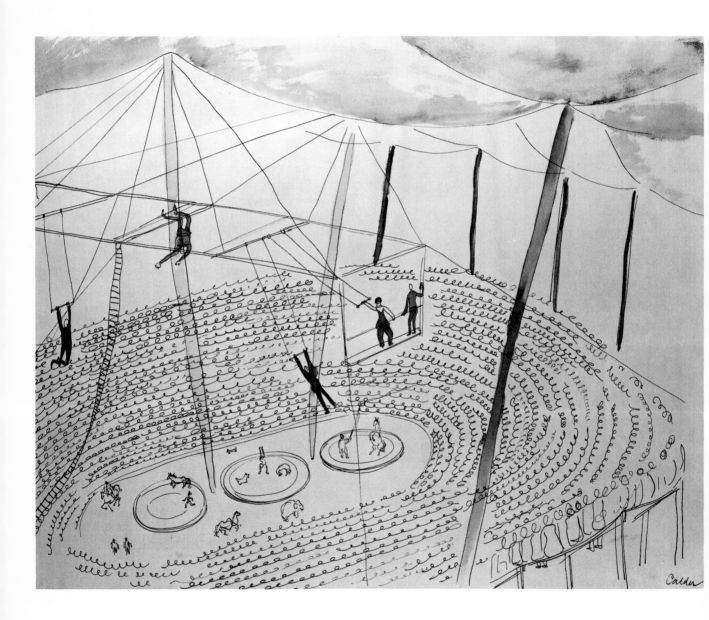

Three-Ring Circus, c. 1930

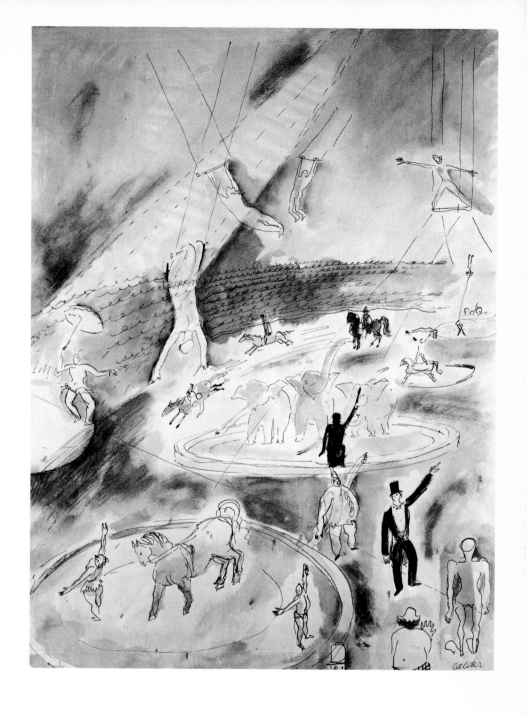

Five-Ring Circus, 1930

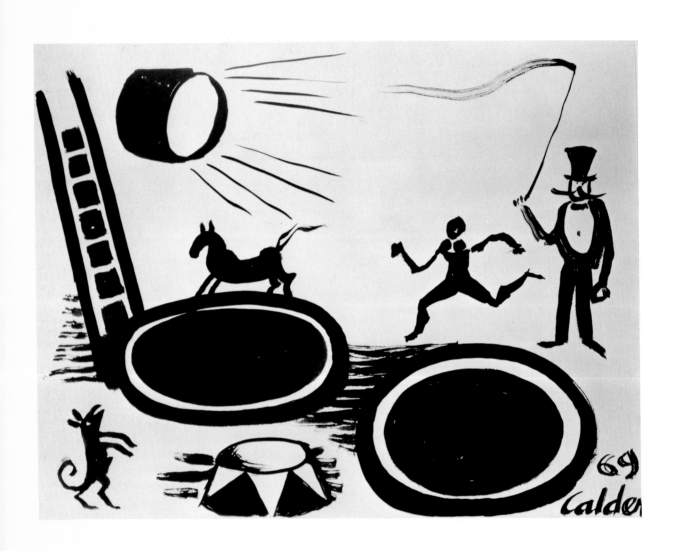

The Spotlight, 1969

There's another thing I like. That's the spotlight
that concentrates on a certain area of the circus.

There was a performer, Lillian Leitzel; she would
come out with the light all on her, and then she did
a hundred flops hanging by her wrist from a wire.
There was a tall man who stood by her and held
her red cape. What I loved was the spotlight on her
and the rest in obscurity.

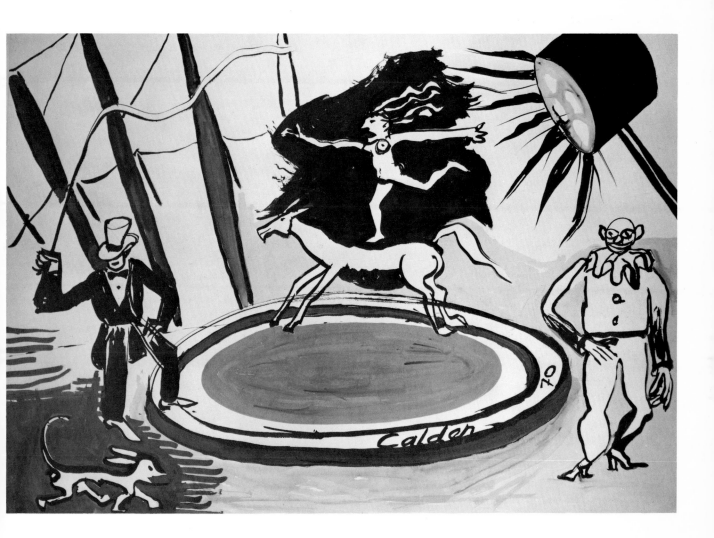

The Red Ring, 1970

I was very fond of the spatial relations. I love the space of the circus. I made some drawings of nothing but the tent. The whole thing of the vast space—I've always loved it.

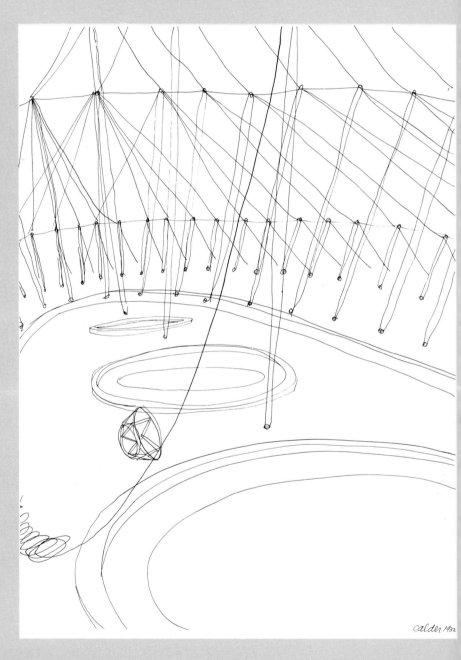

Circus Interior, 1932

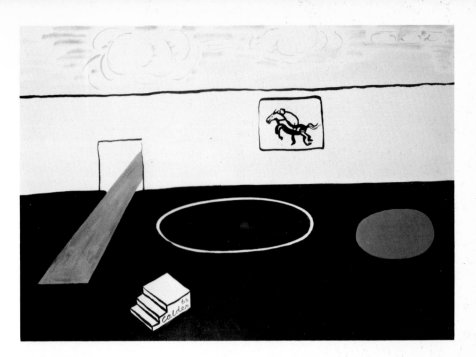

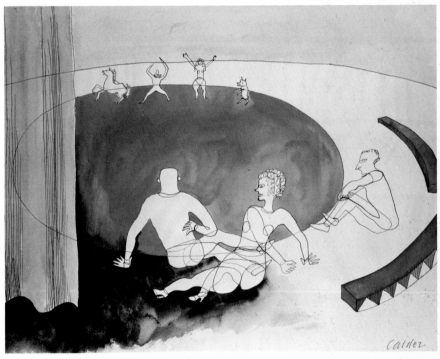

top
The Arena, 1966
bottom
Between the Acts, c. 1930

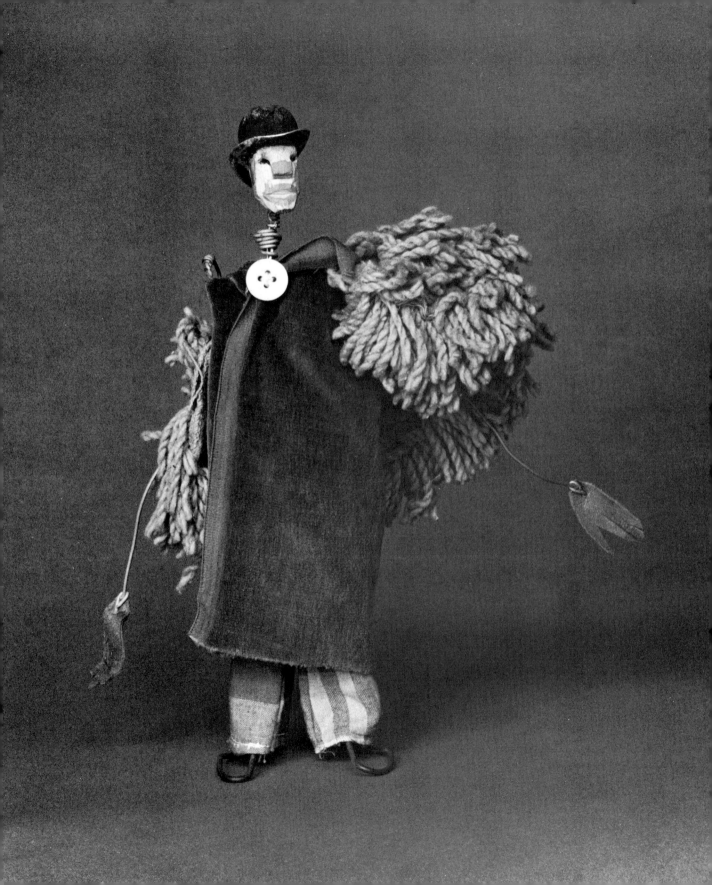

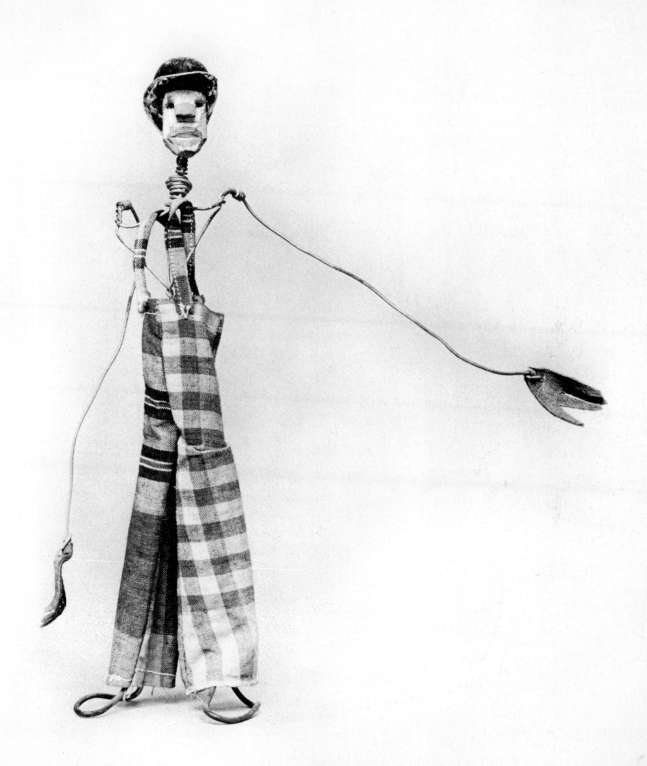

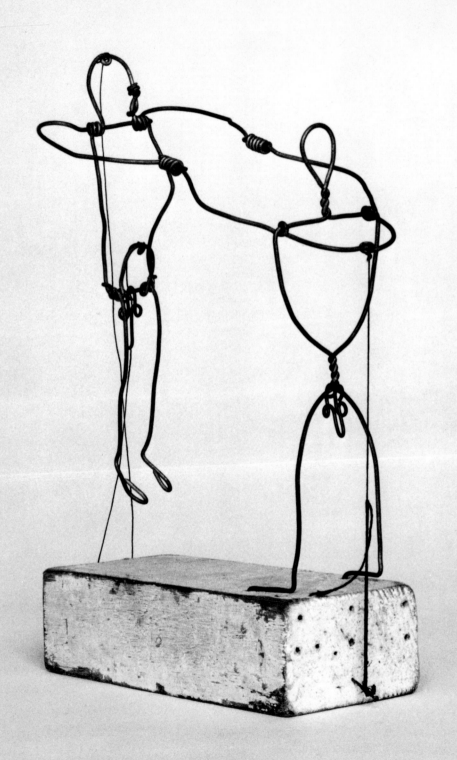

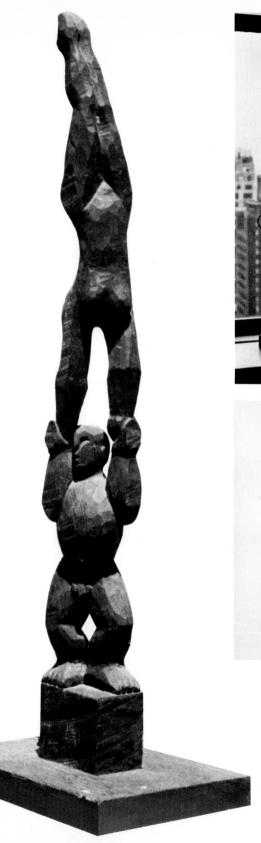

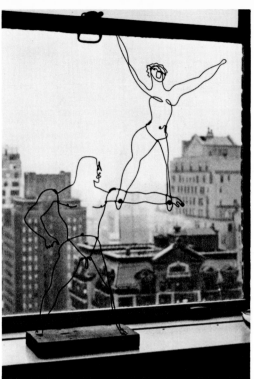

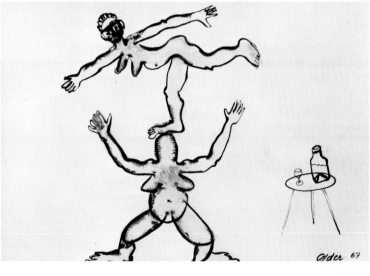

left
Handstand, 1928
top
Acrobats, c. 1930
bottom
Acrobats, 1967

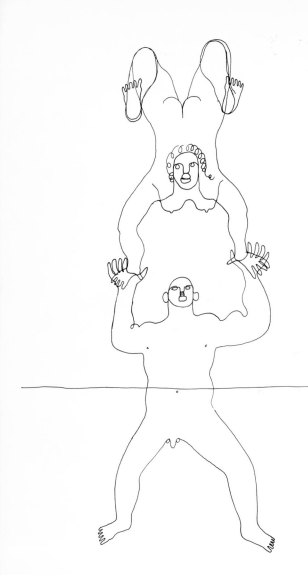

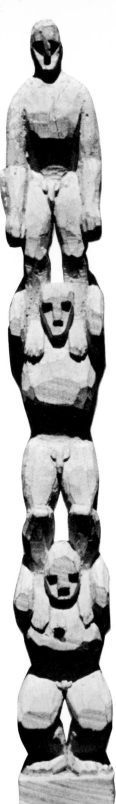

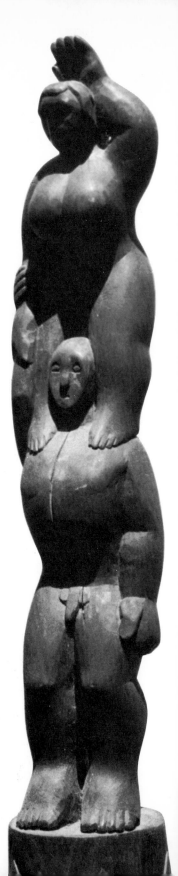

left to right
The Handstand (detail), 1931
Three Men High, 1928
Acrobats, 1926

The previous spring (1944) Wally Harrison had suggested I
make some large outdoor objects which could be done in
cement. He apparently forgot about his suggestion
immediately, but I did not and I started to work in plaster.
I finally made things which were mobile objects and had
them cast in bronze—acrobats, animals, snakes, dancers, a
starfish and tightrope performers. These I showed that fall at
Curt's, I guess it was at the same time *Three Young Rats*
came out.

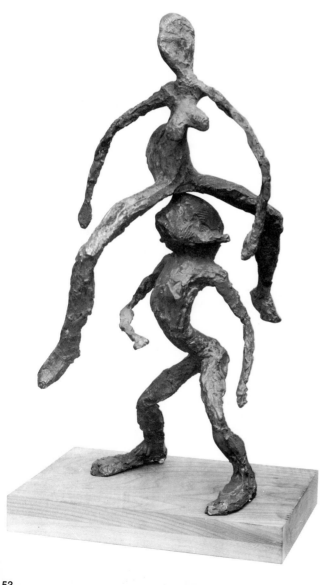

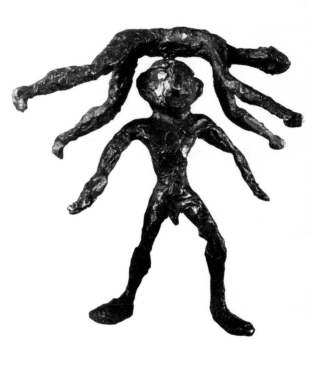

left
Acrobats, 1944
right
Acrobats, 1944

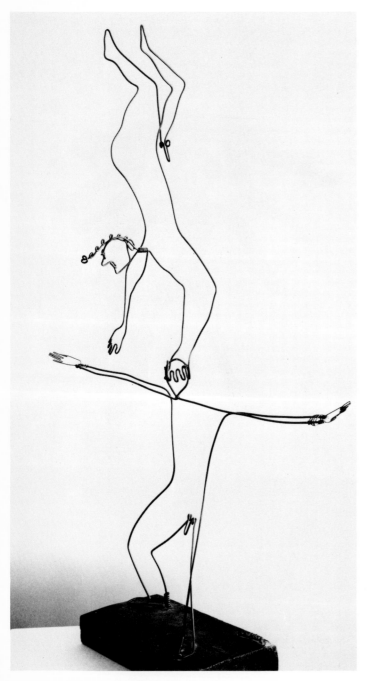

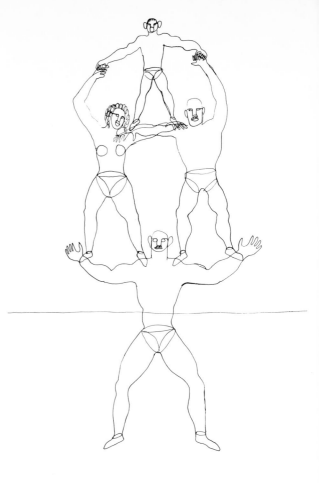

left to right
Acrobats, 1928
Tumbling Family (detail), 1931
The Brass Family, 1927

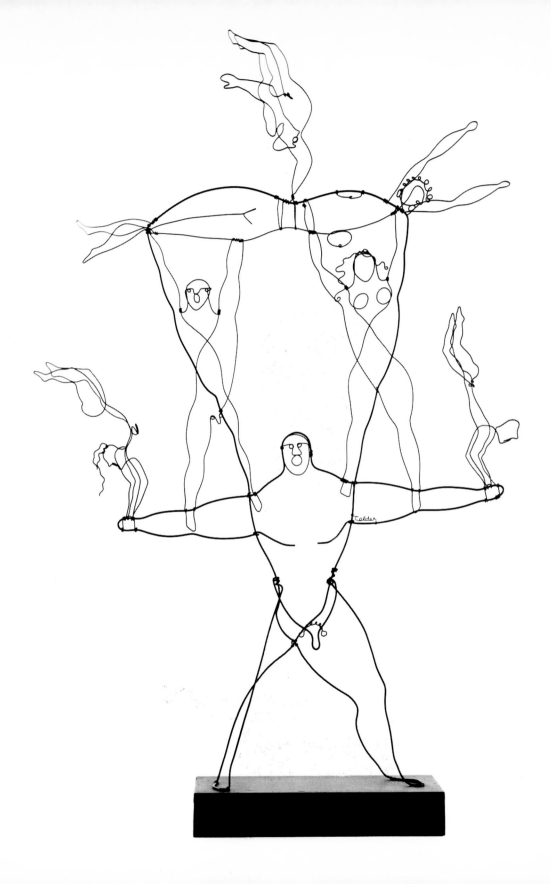

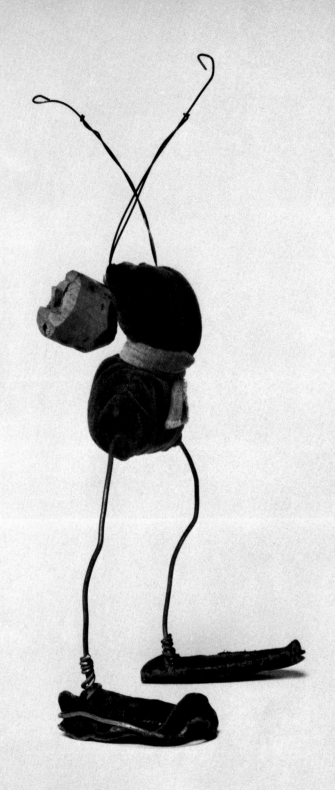

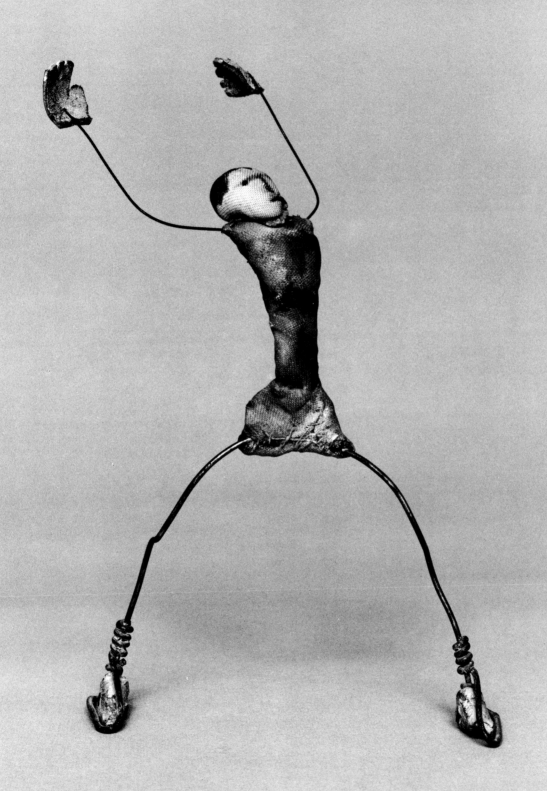

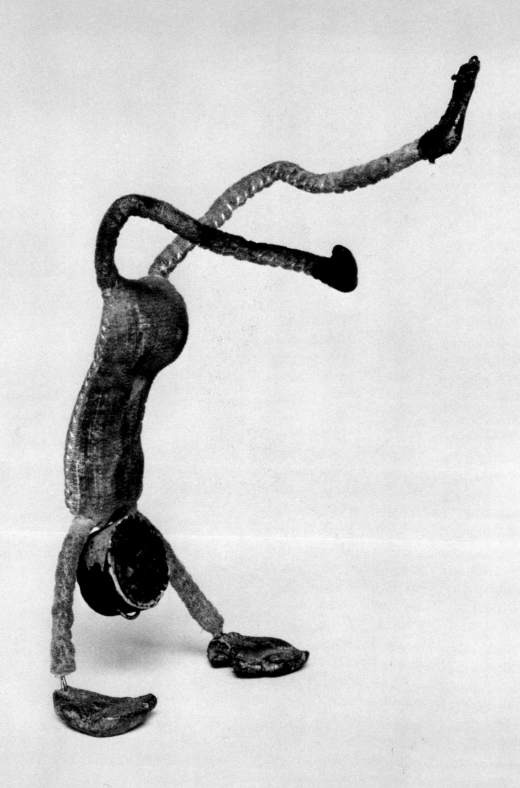

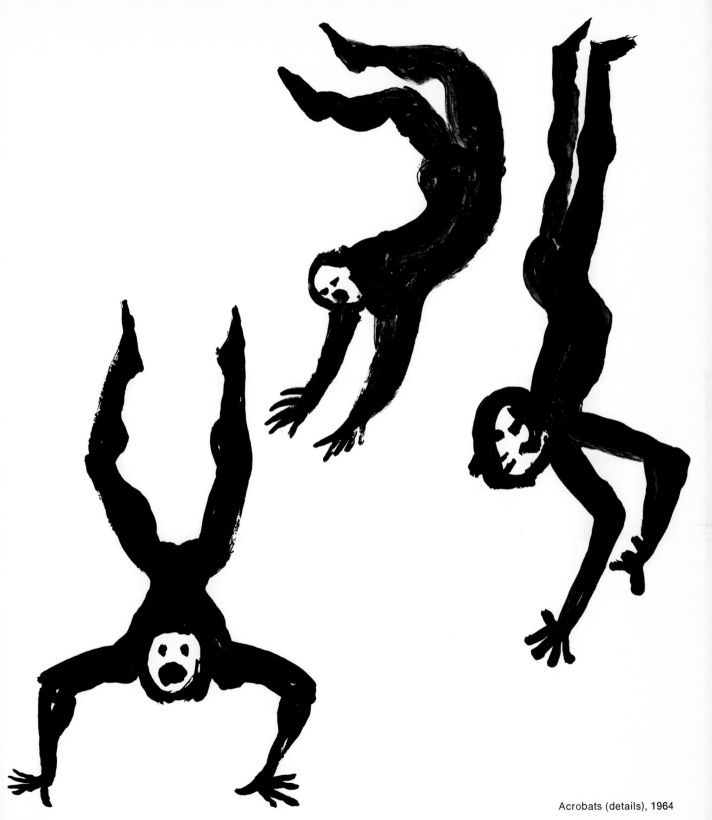

Acrobats (details), 1964

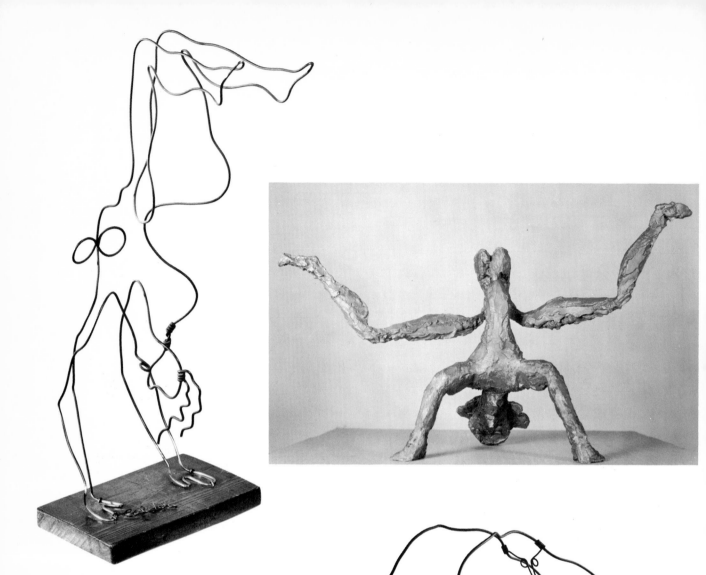

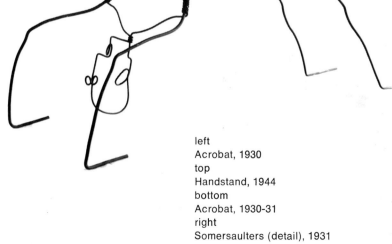

left
Acrobat, 1930
top
Handstand, 1944
bottom
Acrobat, 1930-31
right
Somersaulters (detail), 1931

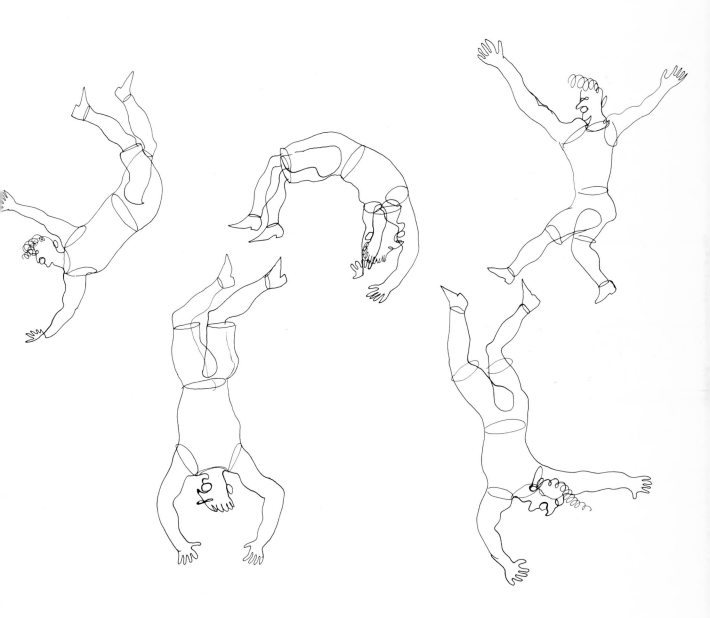

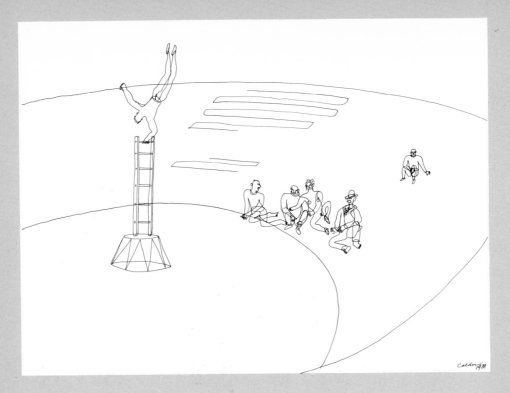

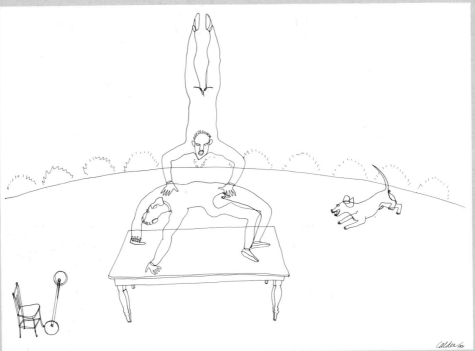

top
Man on Ladder with Troupers, 1931
bottom
Handstand on the Table, 1931

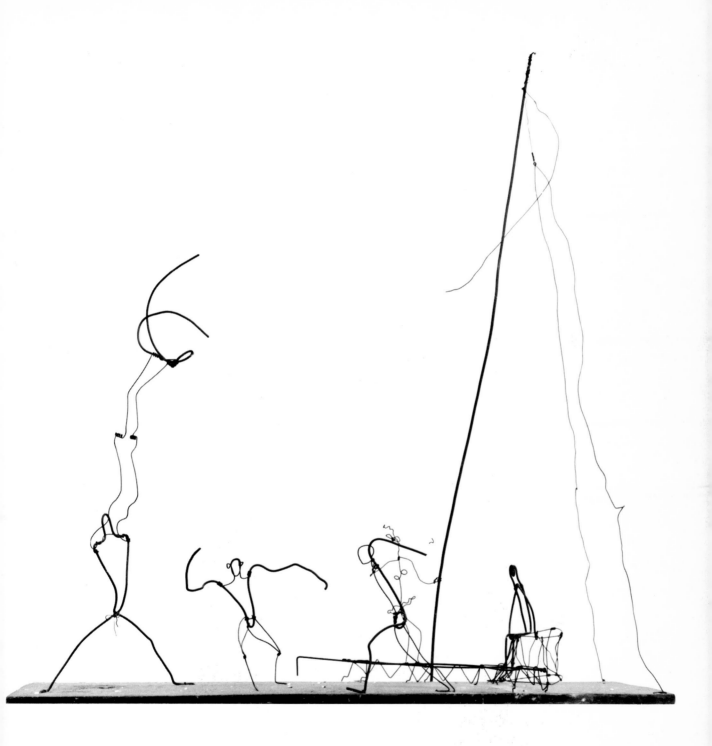

Circus Scene, 1929

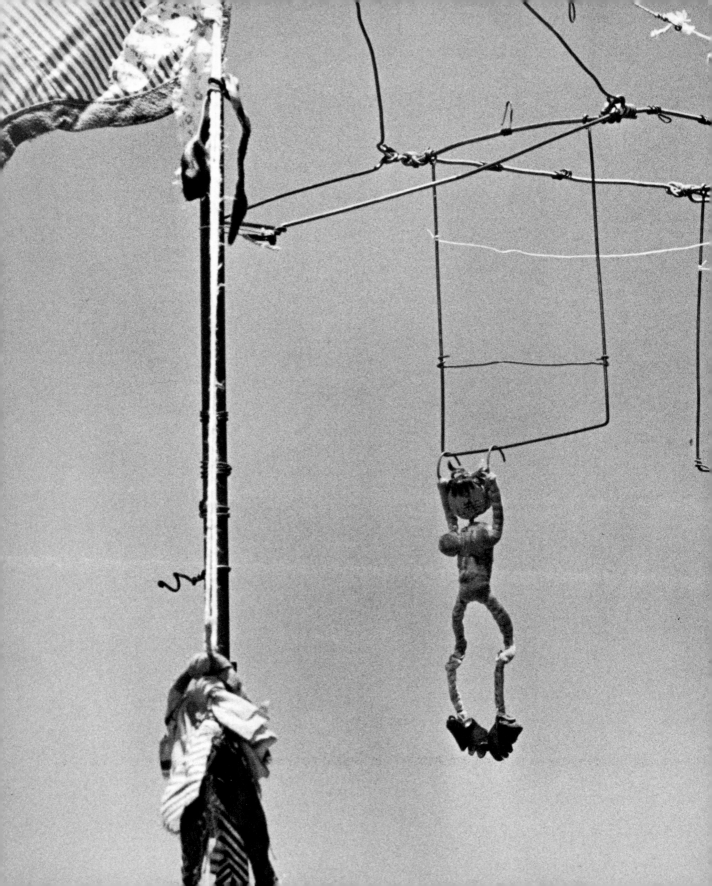

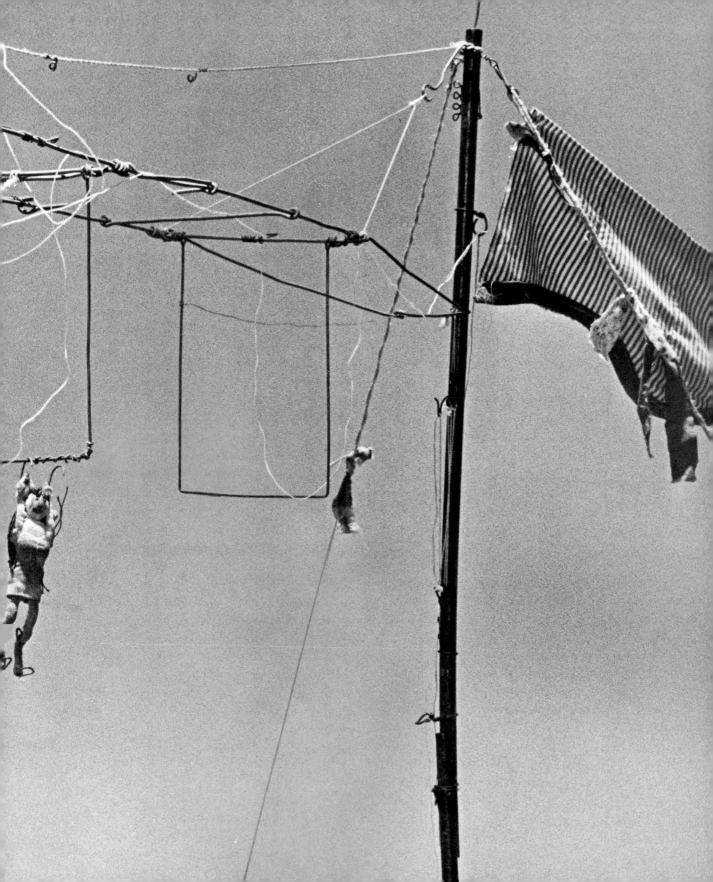

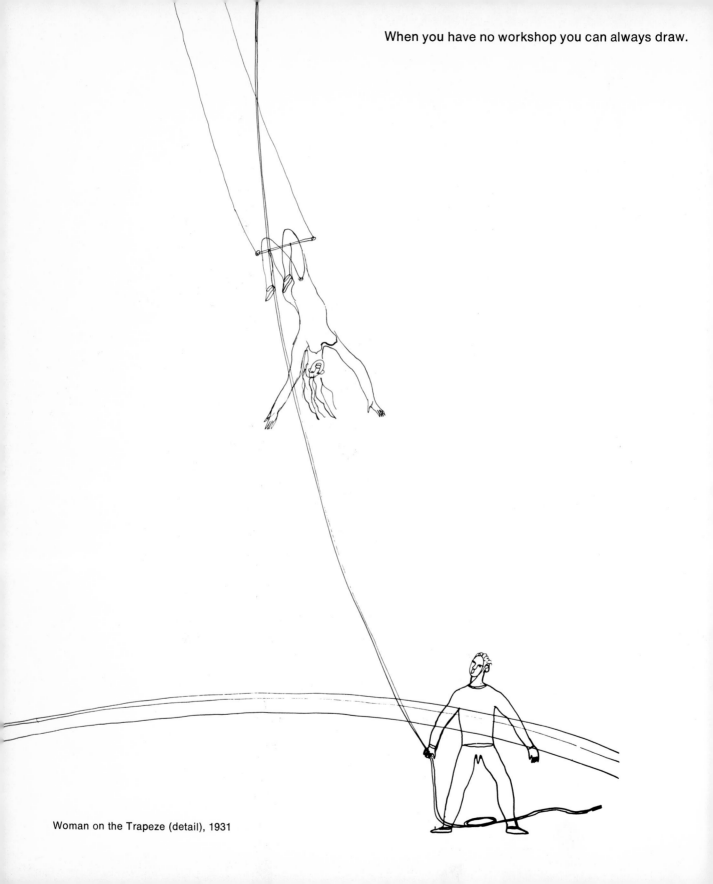

When you have no workshop you can always draw.

Woman on the Trapeze (detail), 1931

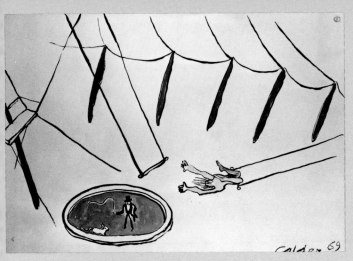

top
Will She Make It?, 1969
bottom
The Catch, 1931

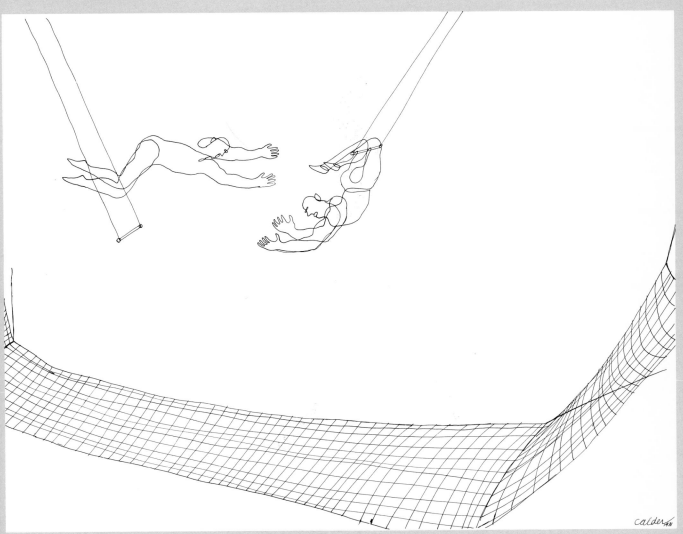

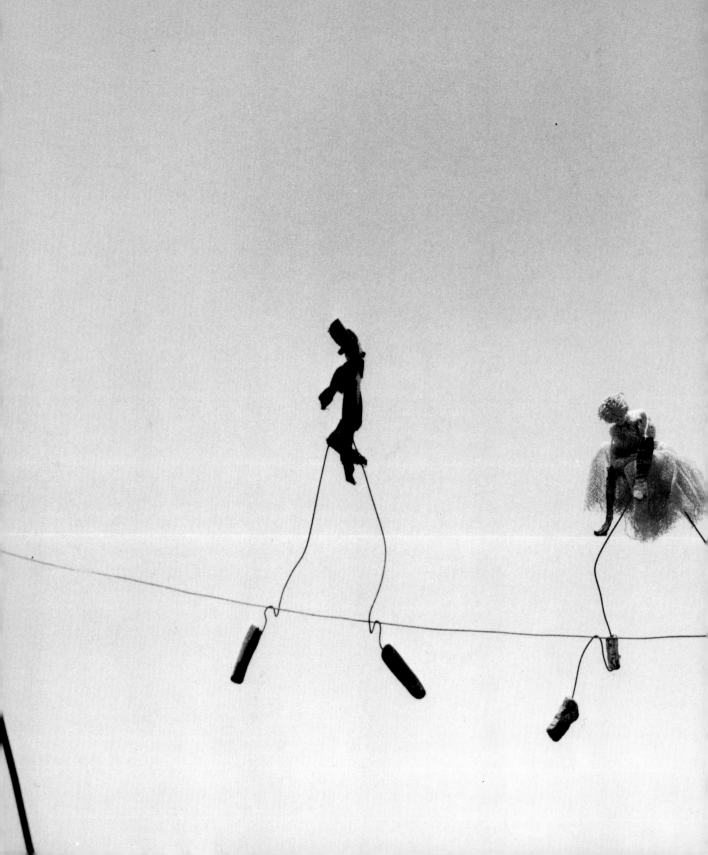

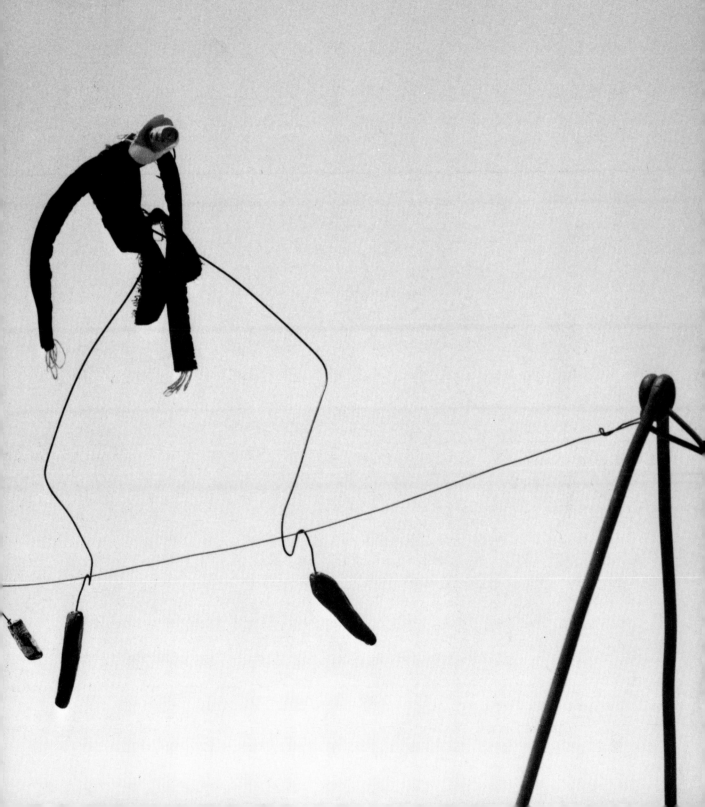

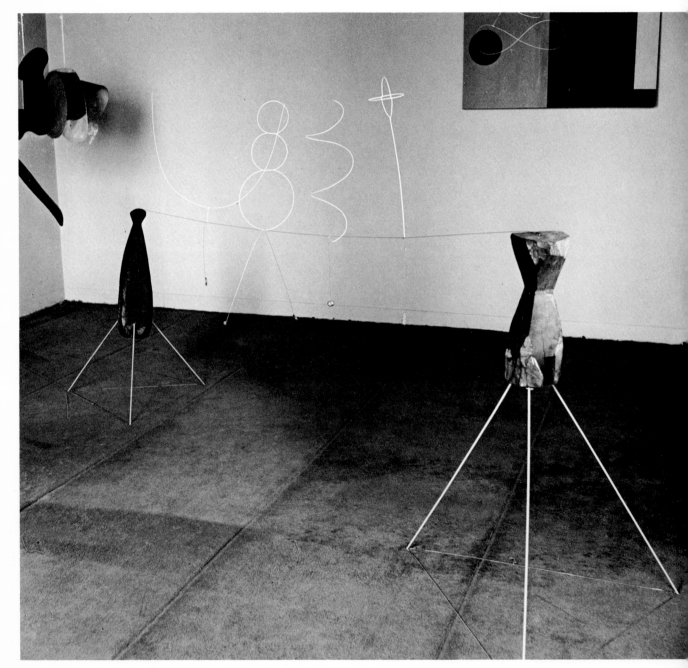

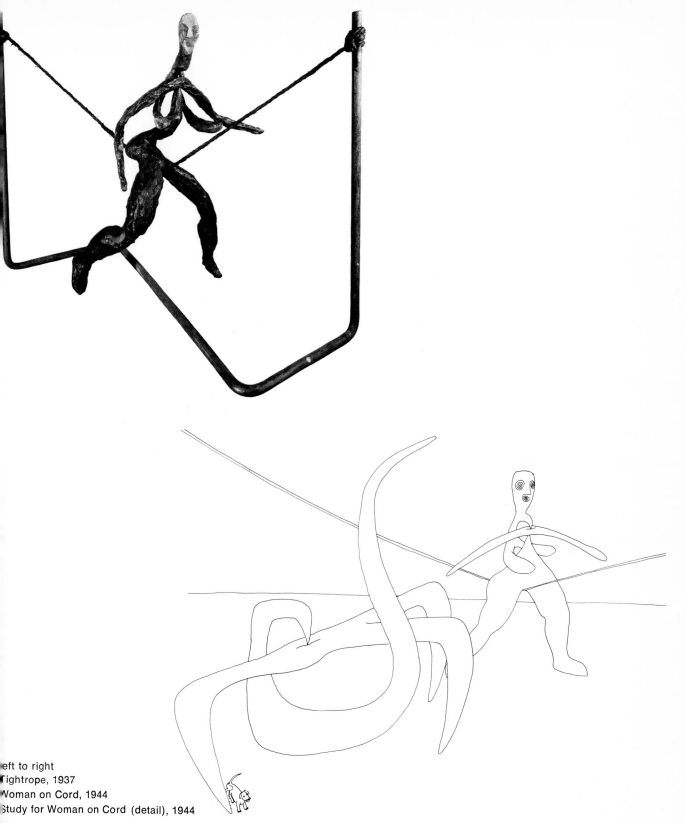

left to right
Tightrope, 1937
Woman on Cord, 1944
Study for Woman on Cord (detail), 1944

71

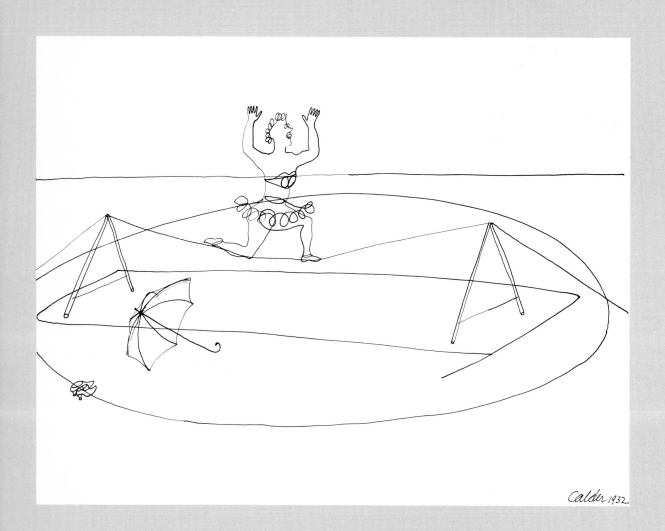

Tightrope Artist, 1932

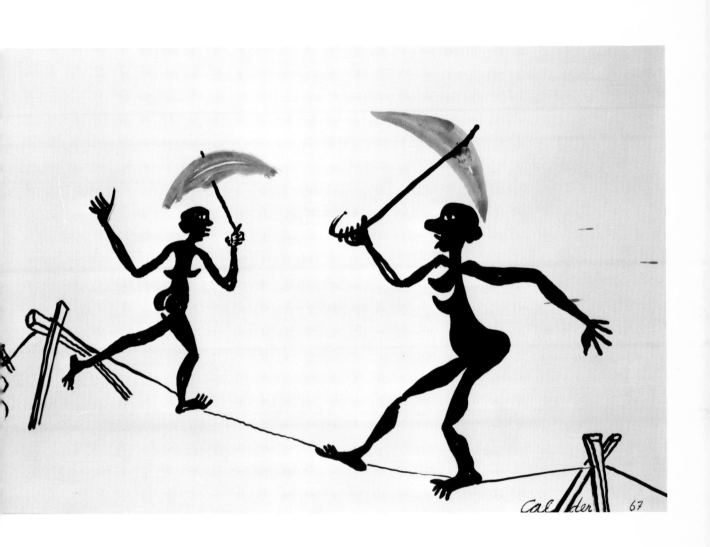

Ladies on a Tightrope, 1967

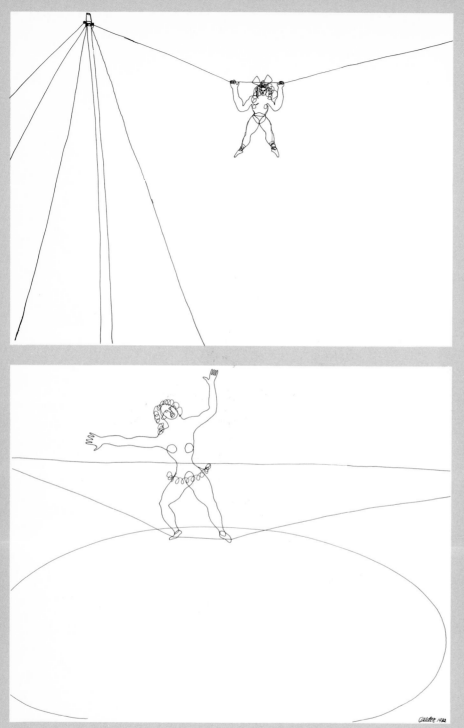

top
Tightrope Artist Hanging by
Her Hands, 1932
bottom
On the High Wire, 1932
right
Tightrope Walker, 1931

74

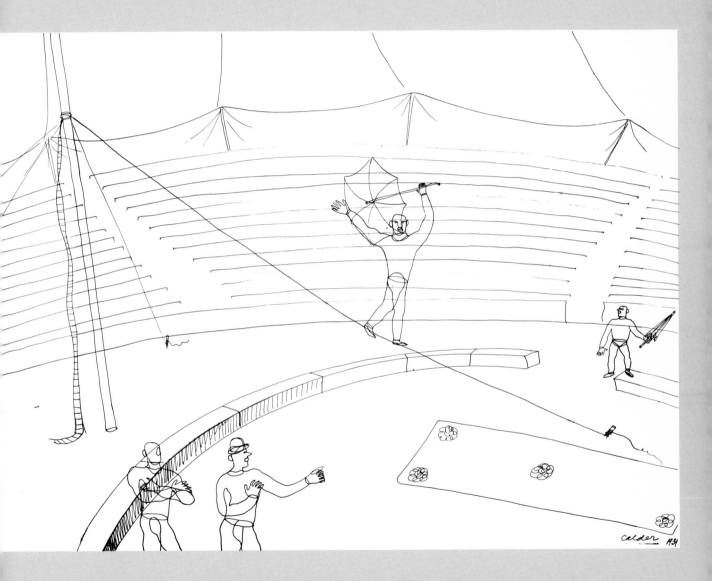

Most people see the surface that's funny,
but there's a lot that goes on . . .

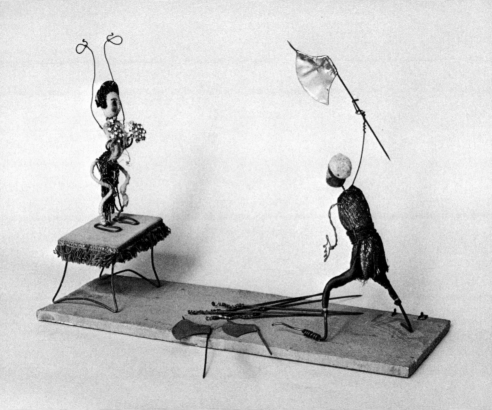

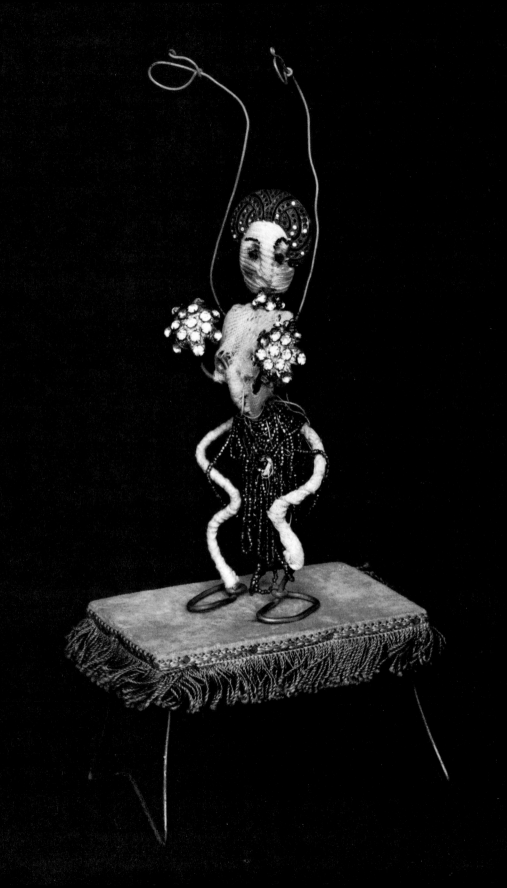

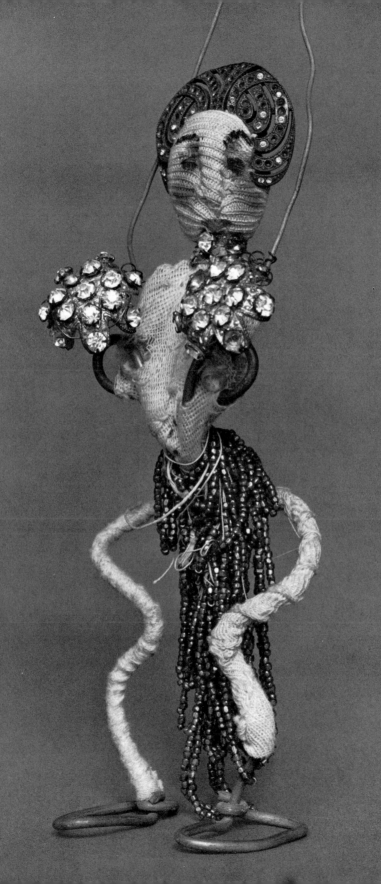

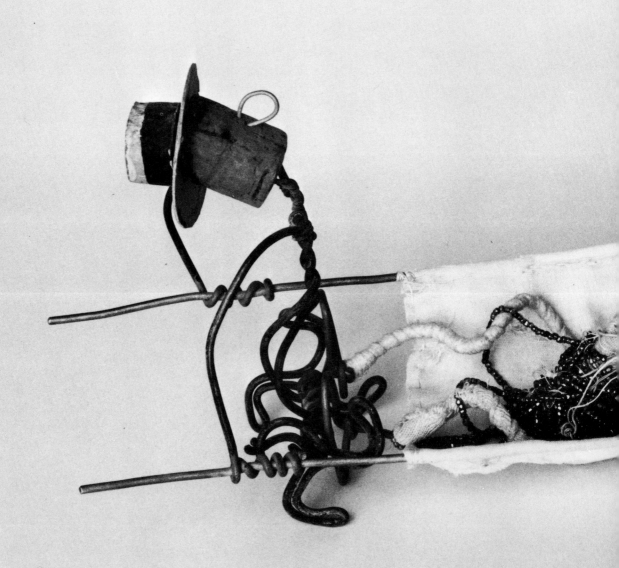

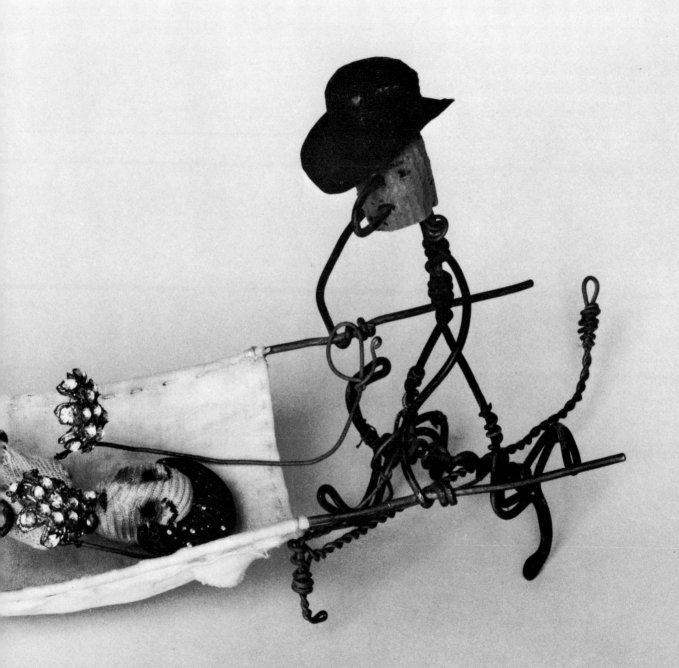

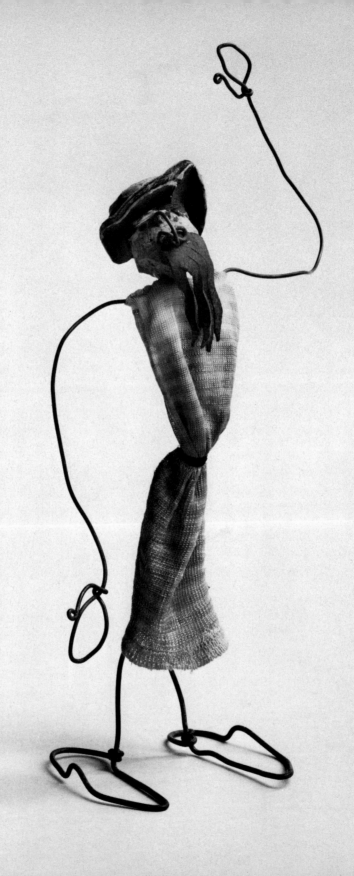

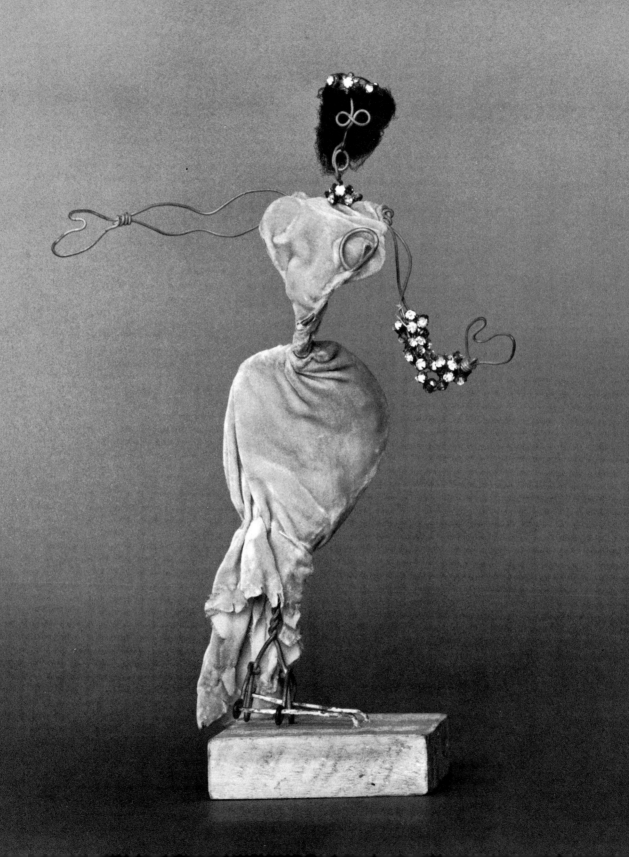

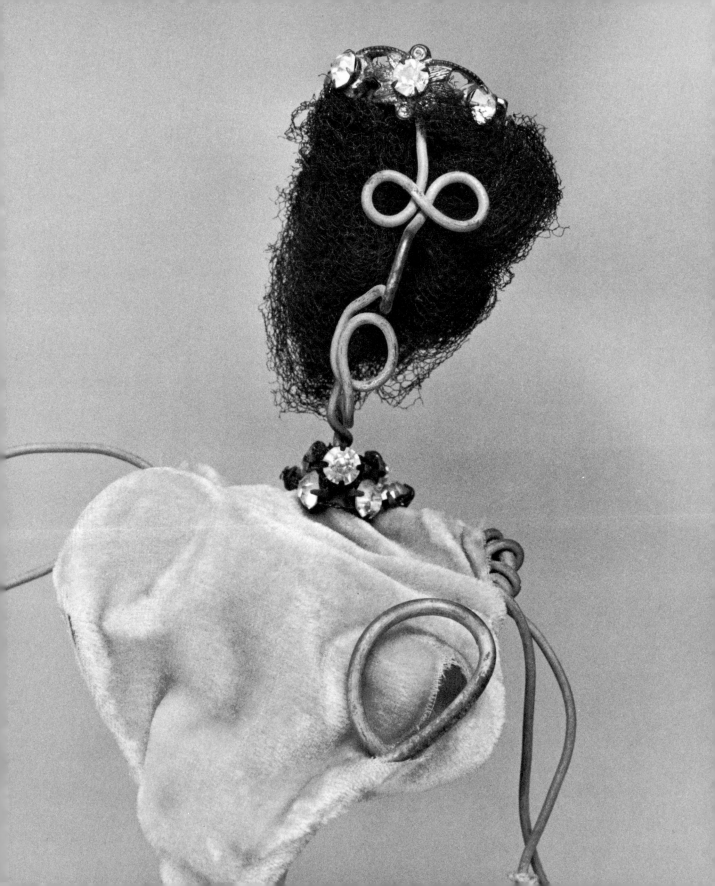

Miró arrived at my studio one day when I happened to be doing the circus. I guess he enjoyed it. A few years later, in 1932, having seen the circus again in his house at Montroig in Spain, he told me the next morning:

"I liked the bits of paper best."

These are little bits of white paper, with a hole and slight weight on each one, which flutter down several variously coiled thin steel wires, which I jiggle so that they flutter down like doves onto the shoulder of a bejeweled circus belle-dame.

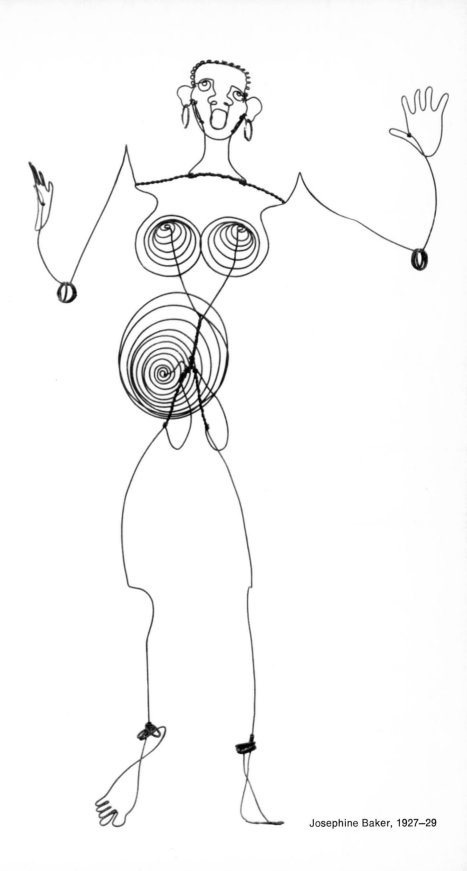

Josephine Baker, 1927–29

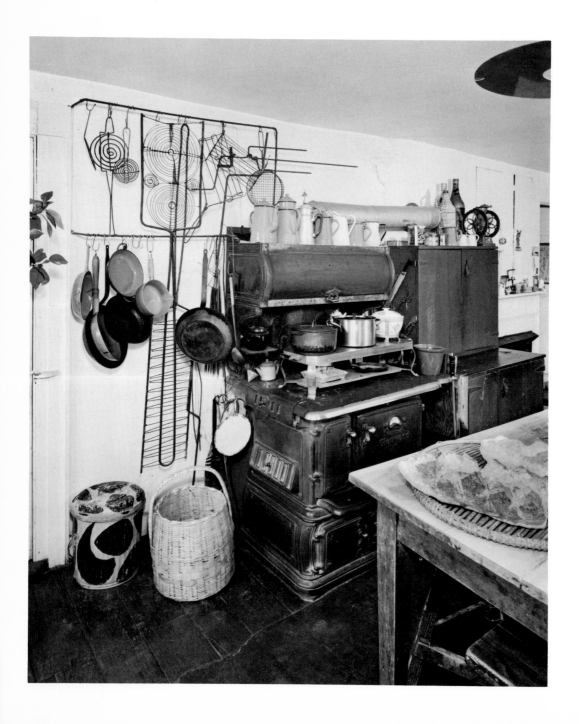

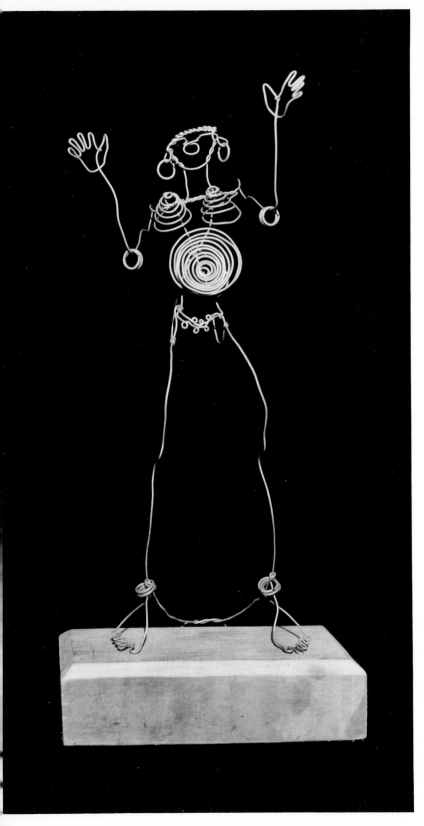

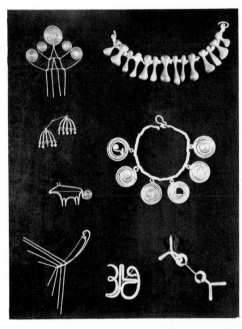

left to right
Wire kitchenware, 1930s
Josephine Baker, 1926
Jewelry, c. 1940

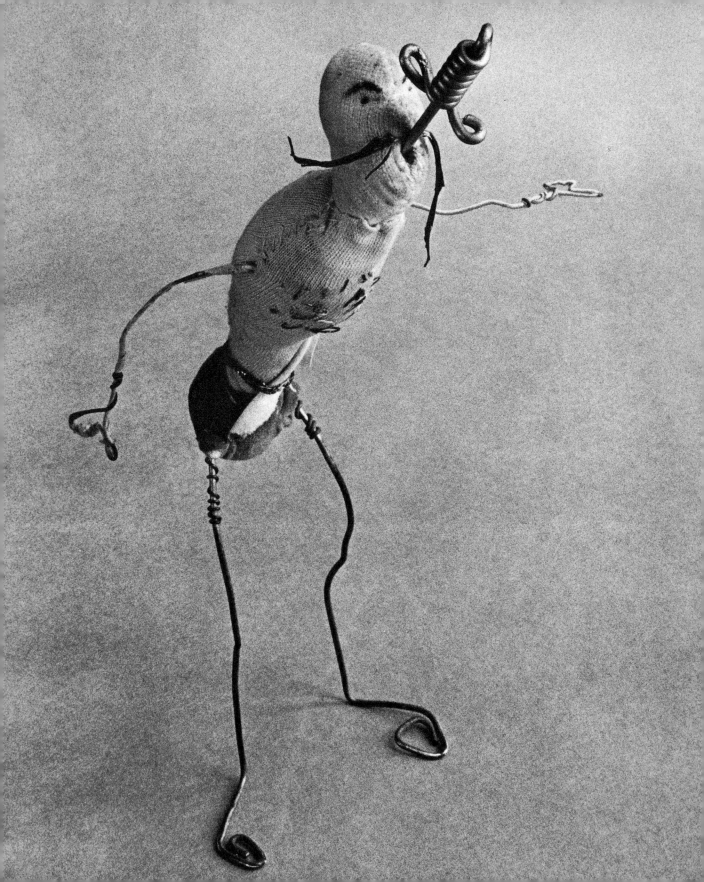

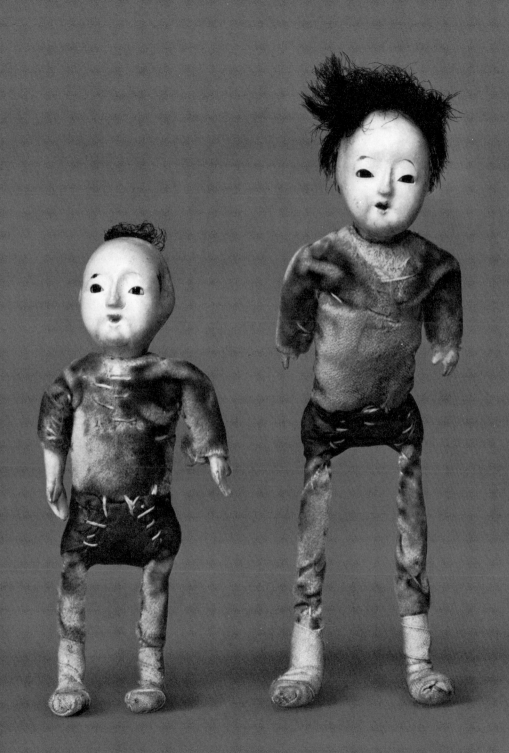

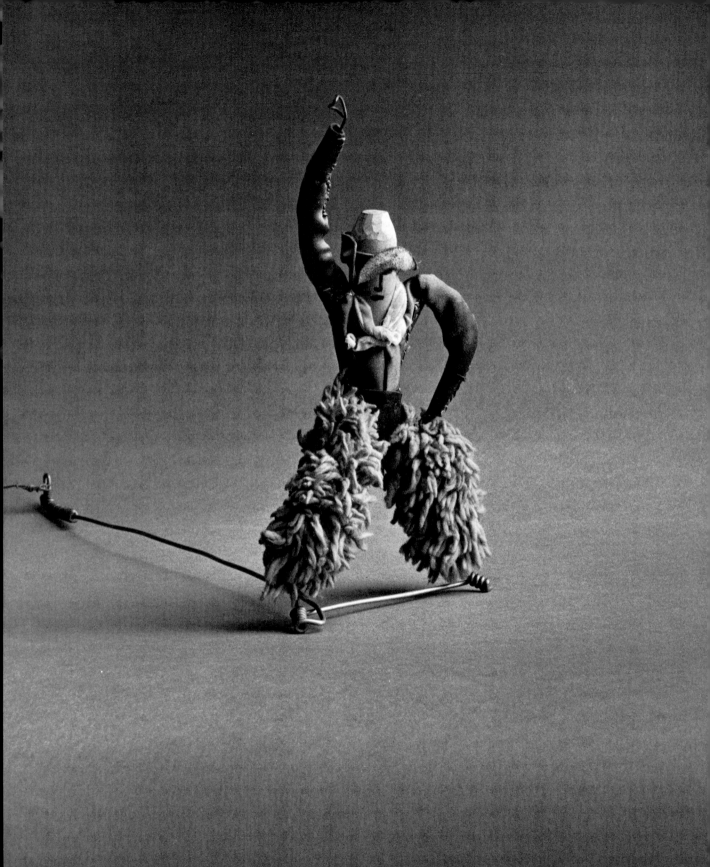

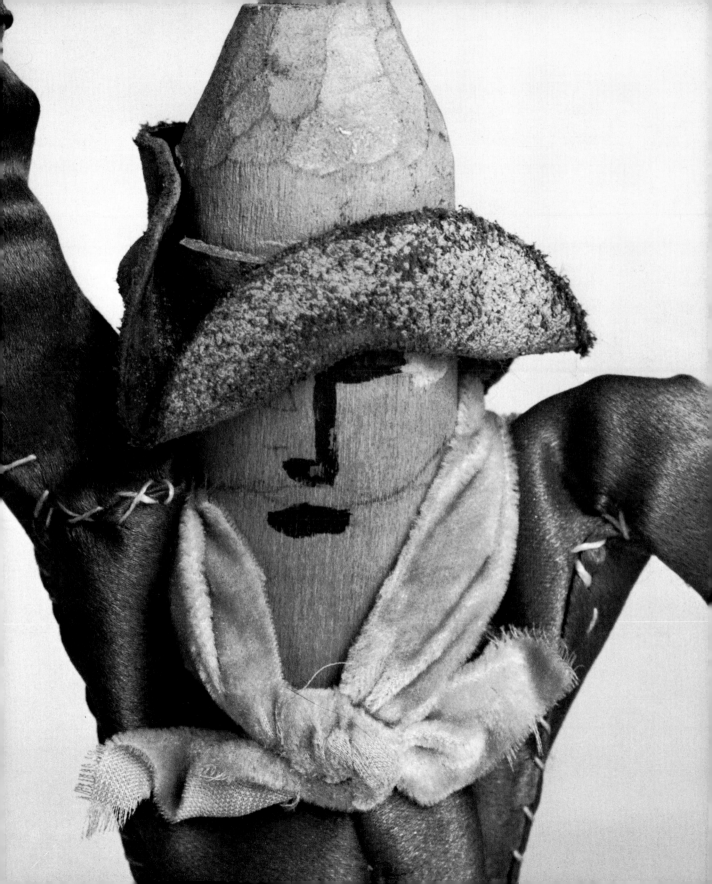

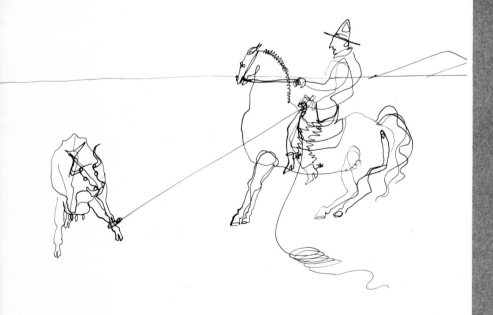

Rodeo Style (detail), 1932

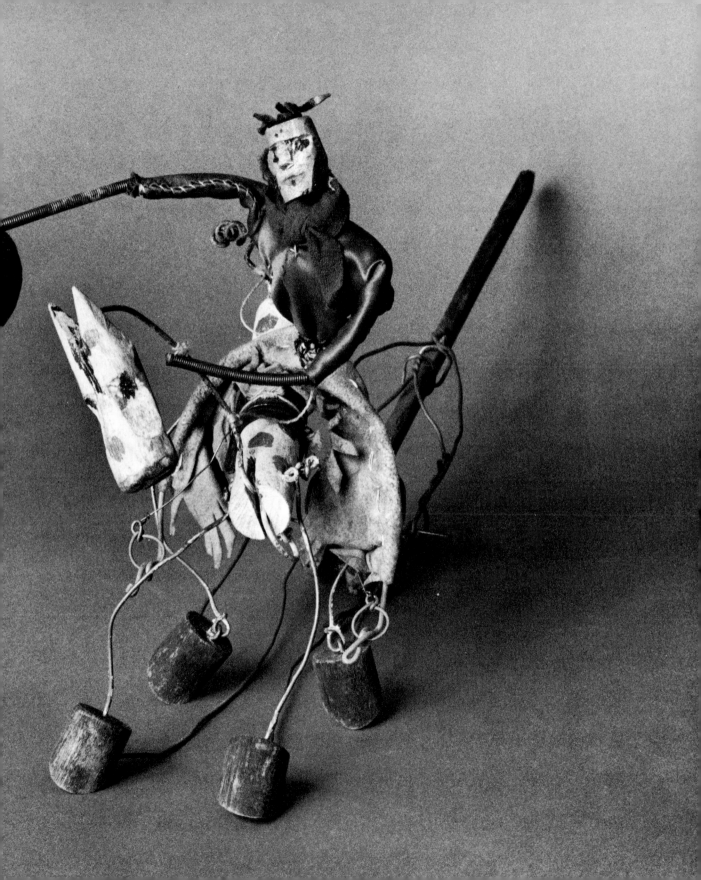

ANIMALS—ACTION. These two words go hand in hand in art . . . there is always a feeling of perpetual motion about animals and to draw them successfully this must be borne in mind.

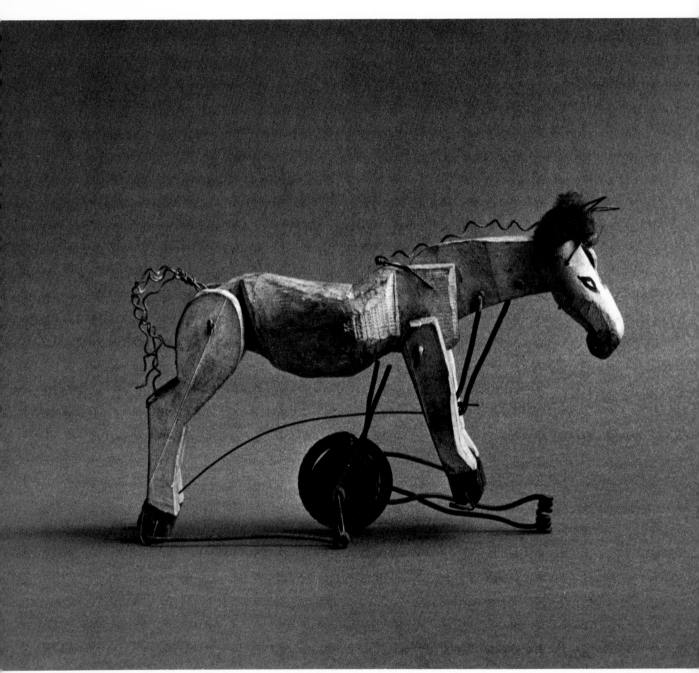

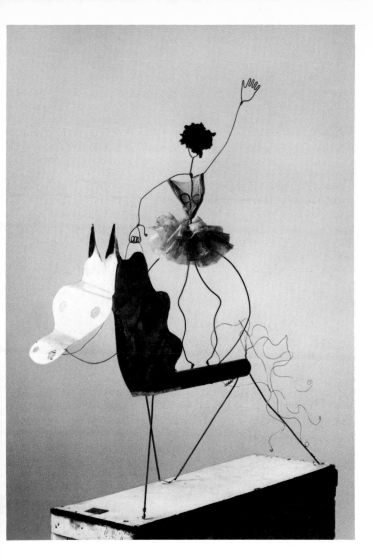

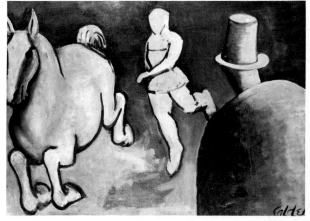

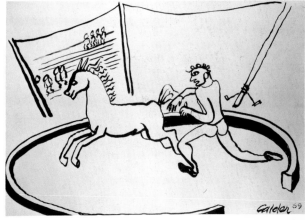

left
Bareback Rider, c. 1929
top
Circus, 1926–27
bottom
Before the Leap, 1969

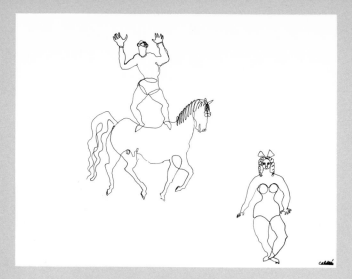

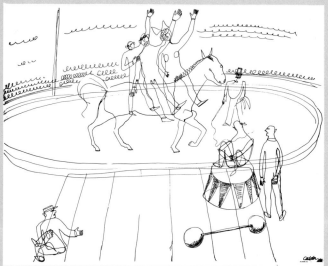

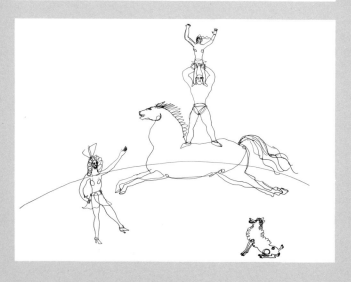

The big circus drawings were made in France. I made some
smaller ones a year later on the Cape; the Philadelphia Museum
has a set of these. Every once in a while I'd get going.

Now and then you get out of your bailiwick and then you don't
know what to do, so the best thing is to make drawings.

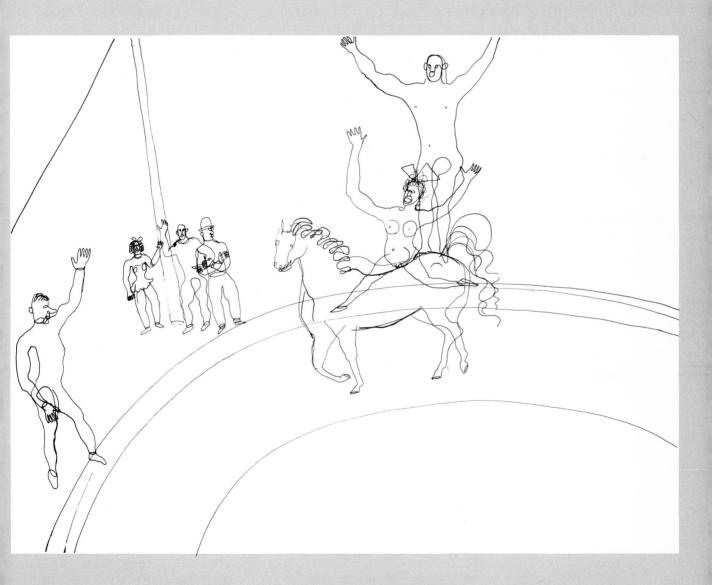

left, top to bottom
The Horseback Performance, 1931
Three on a Horse, 1931
Bareback Family Group, 1932
above
Bareback Act, 1931

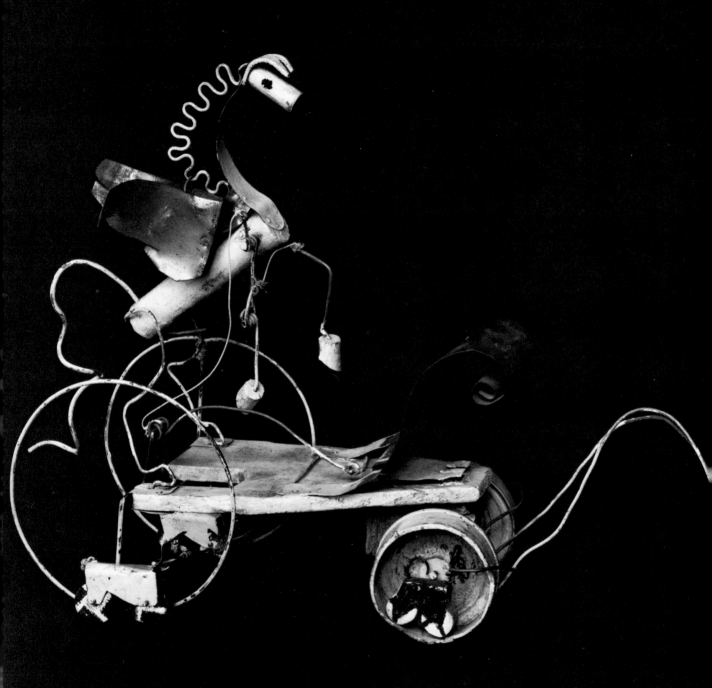

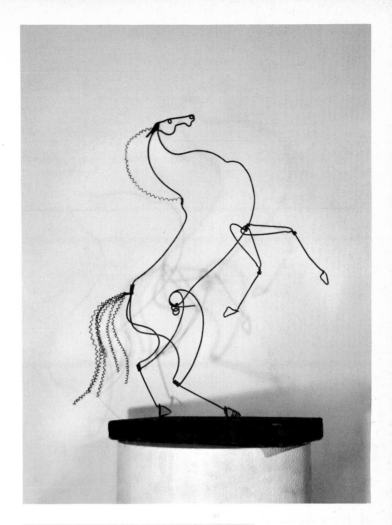

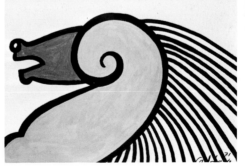

top
Horse, 1928
bottom
Equine, 1971

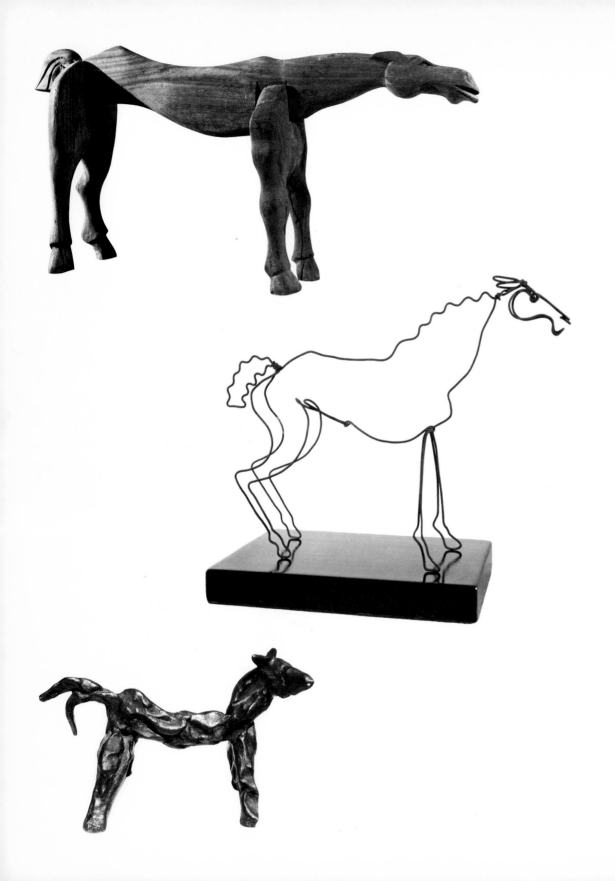

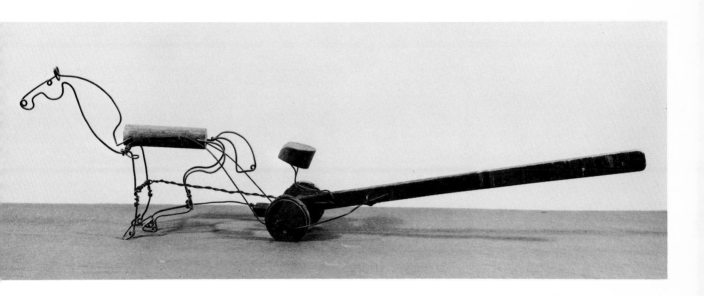

Stallion, c. 1950

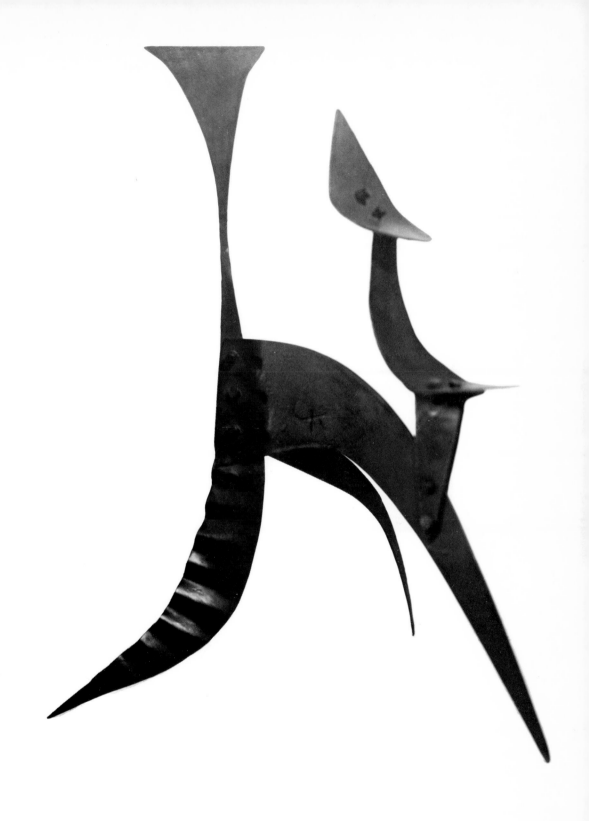

Horse and Rider, c. 1946

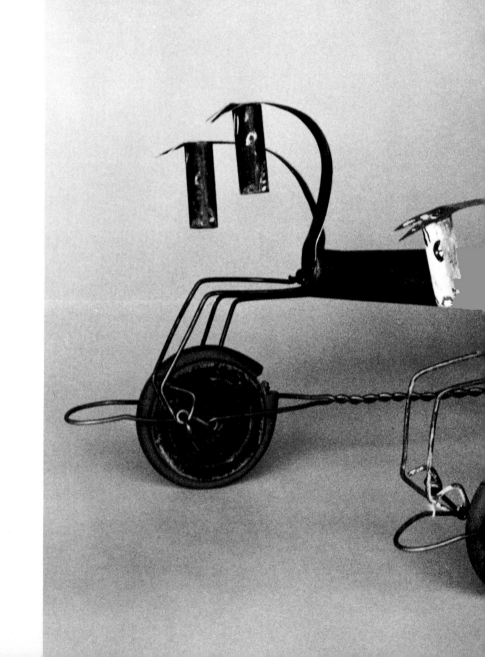

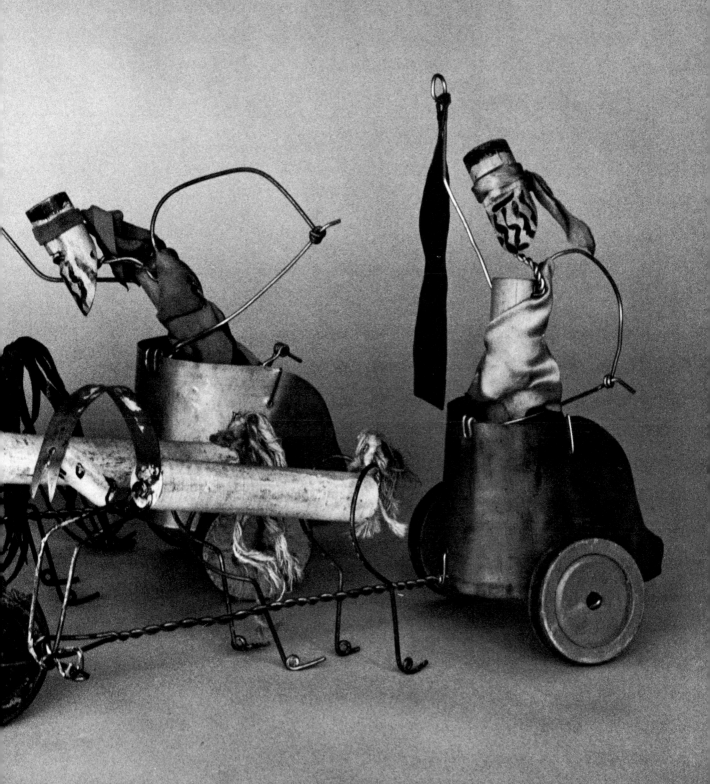

left
Ben Hur (detail), 1931
above
The Chariot, 1961

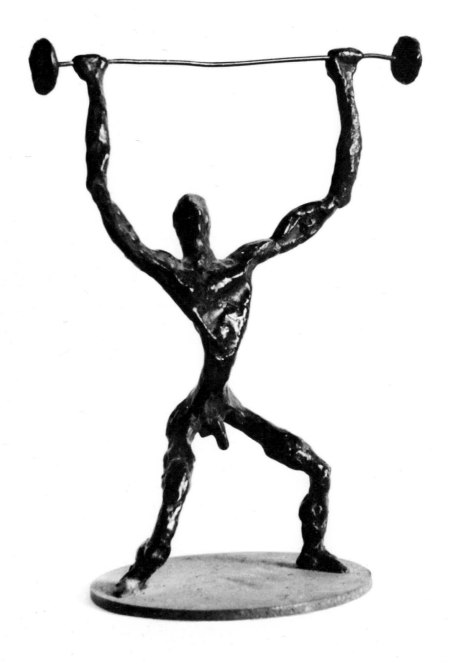

Weight Lifter, 1930

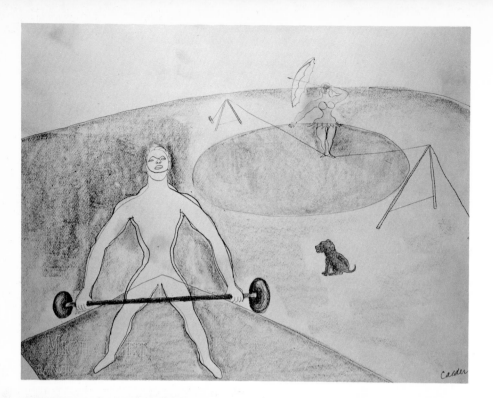

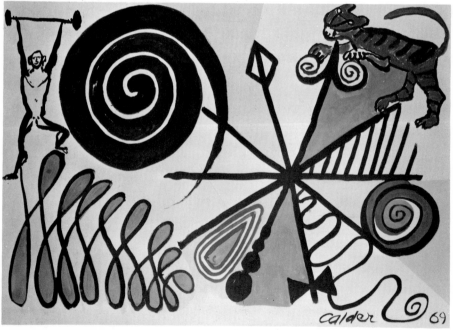

top
Weight Lifter, c. 1931
bottom
Monkey and Tiger, 1969

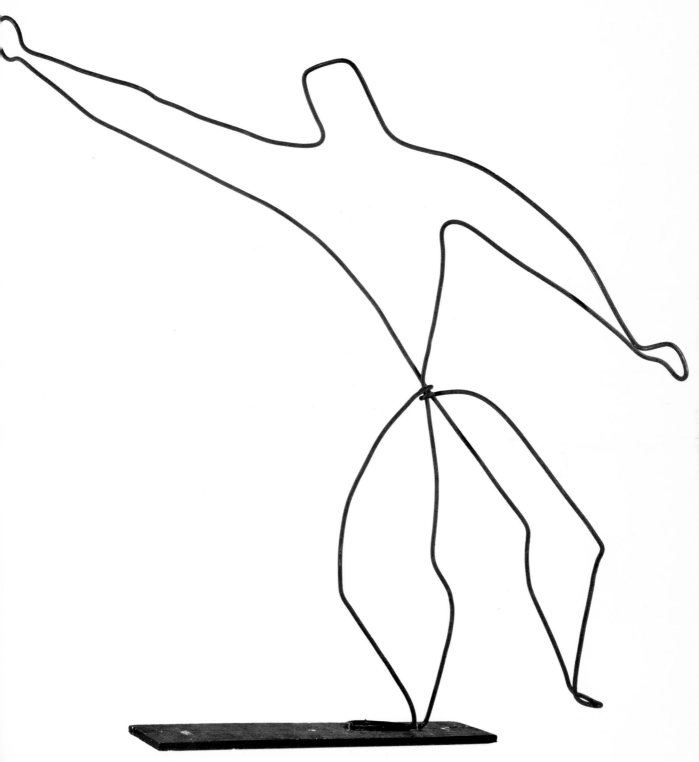

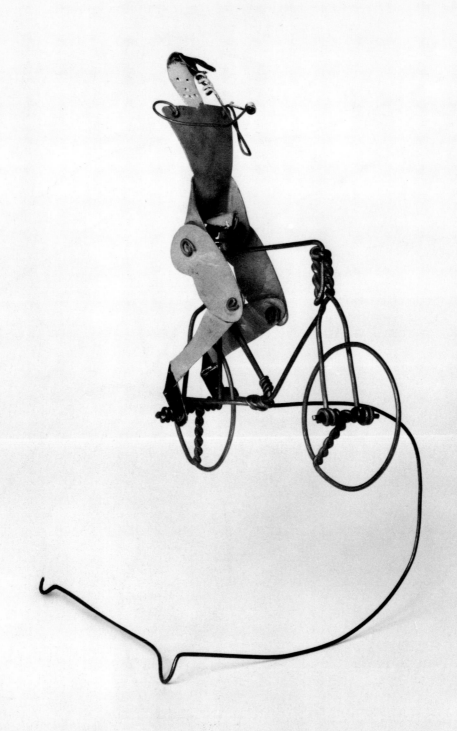

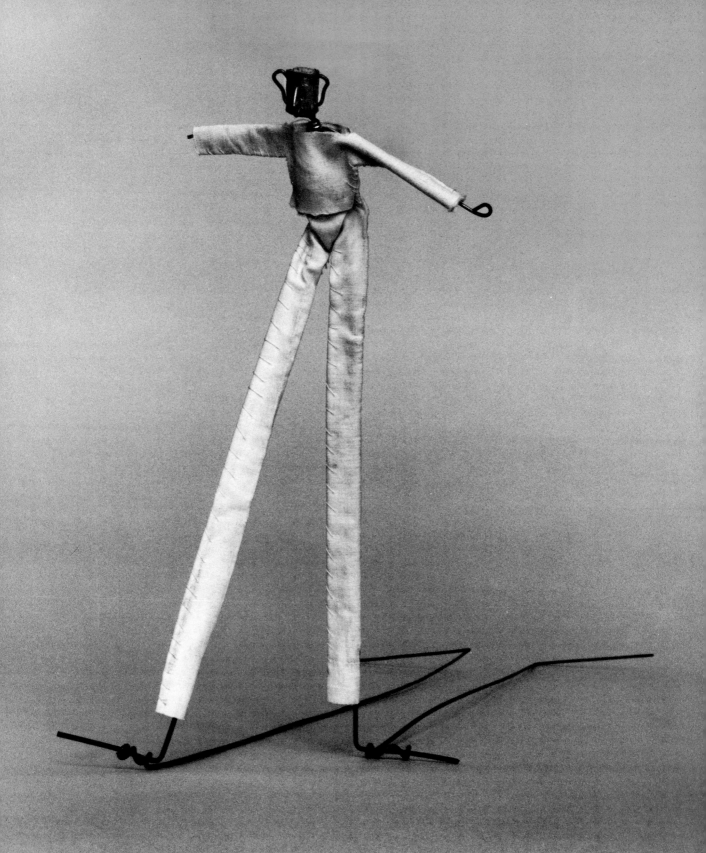

Cycle Act, 1931

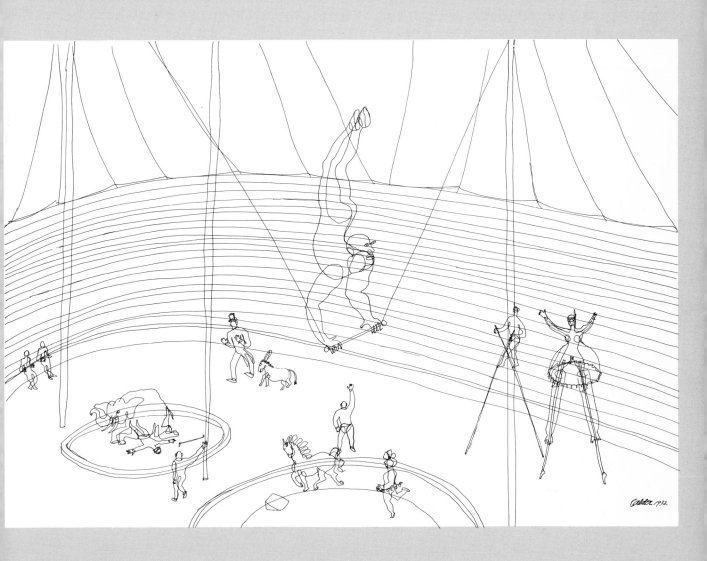

The Circus, 1932

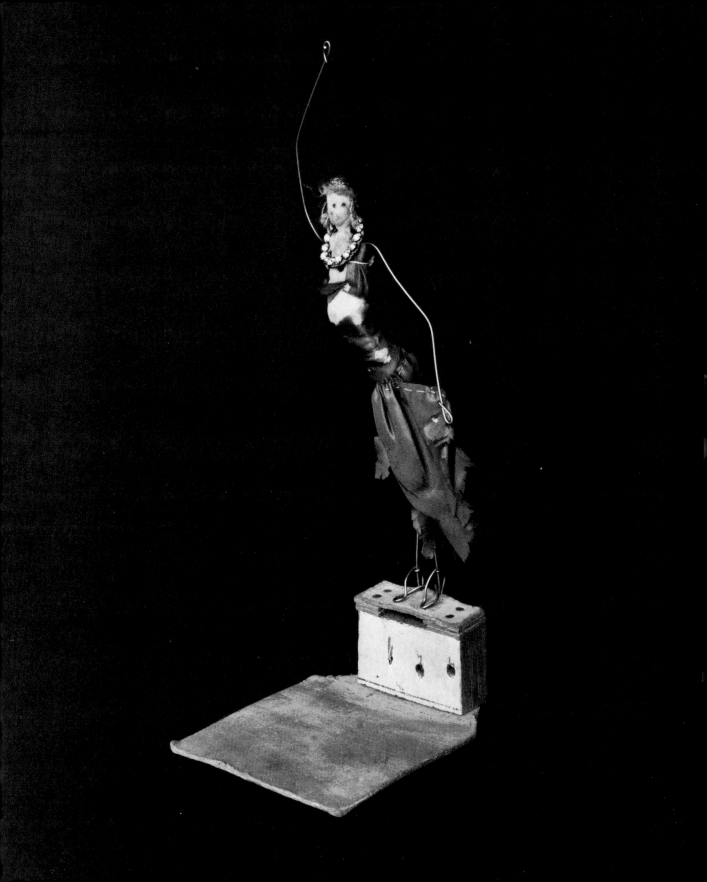

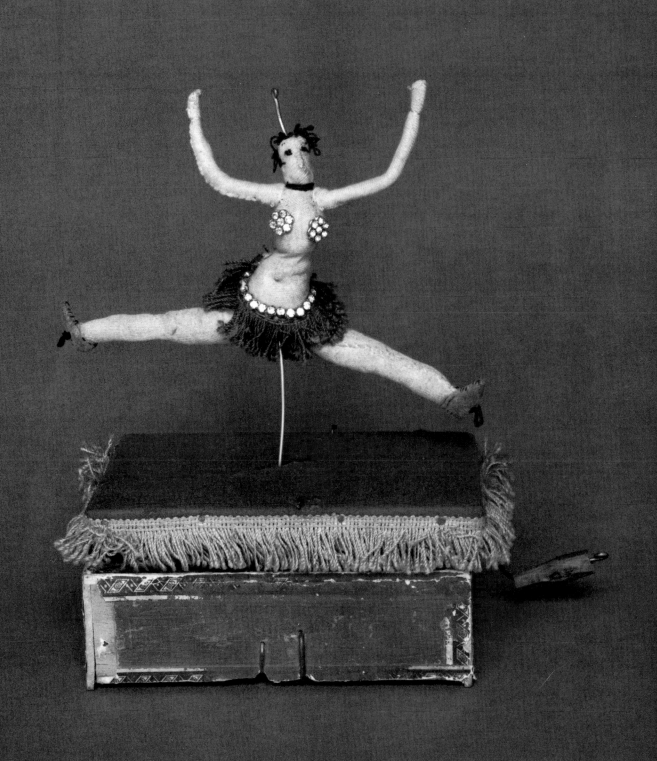

THE LION. We marvel at the tireless
energy of the King of Beasts and his
lioness pacing before the bars. How
kingly and courageous they seem
whenever we see them. Even in the
circus where they supposedly are
tamed, they seem ever to be on the
verge of breaking loose.

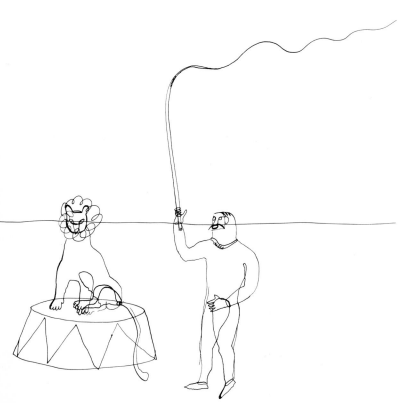

In the Spotlight (detail), 1932

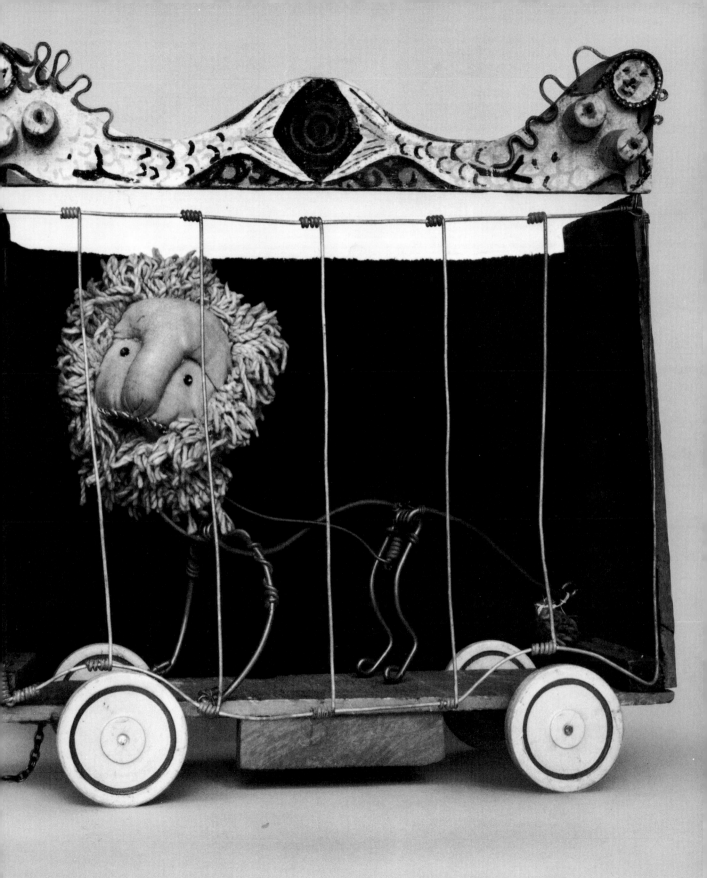

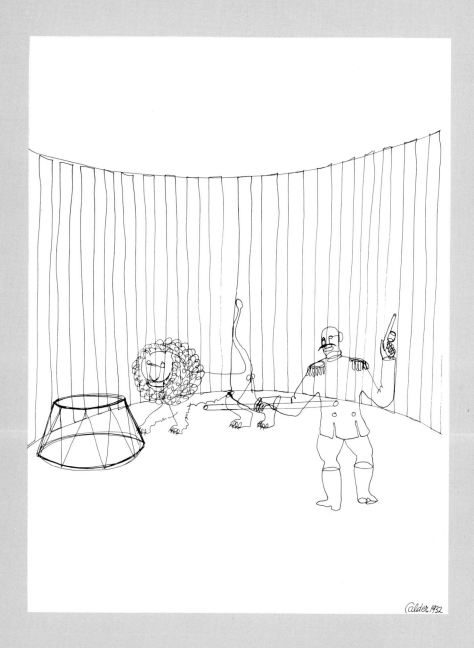

Lion Tamer, 1932

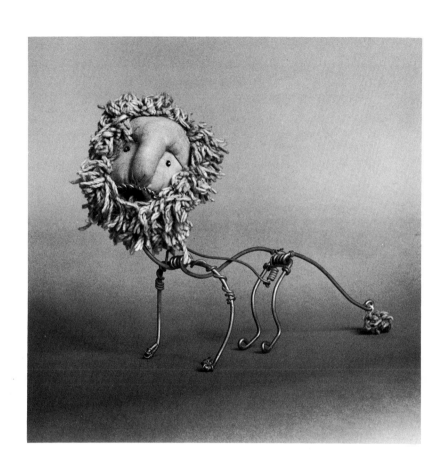

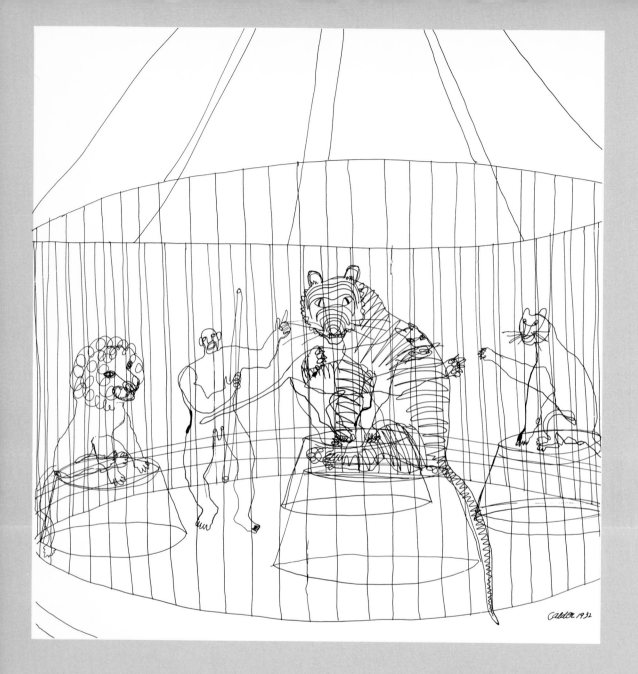

The Wild Beast Cage, 1932

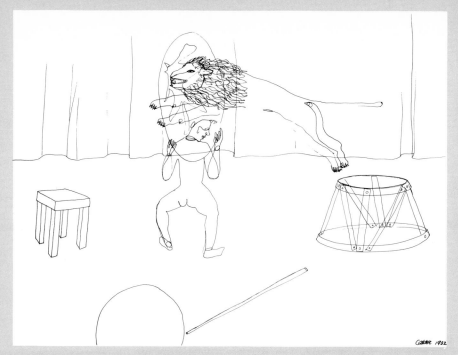

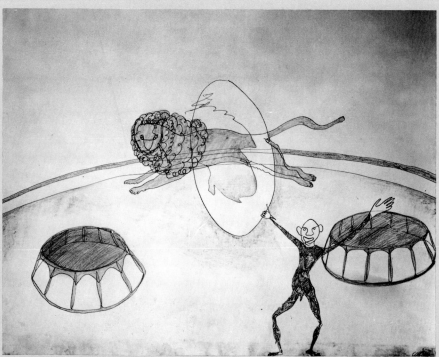

top
Through the Hoop, 1932
bottom
Lion's Leap, 1931

They call me a "playboy," you know.
I want to make things that are fun to
look at, that have no propaganda value
whatsoever.

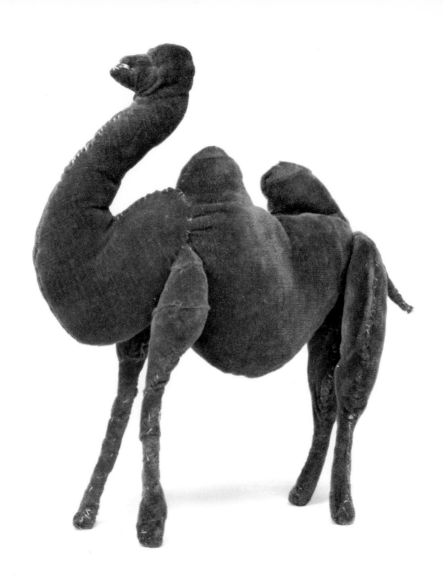

I guess I've always liked elephants.

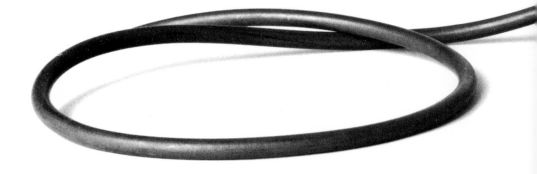

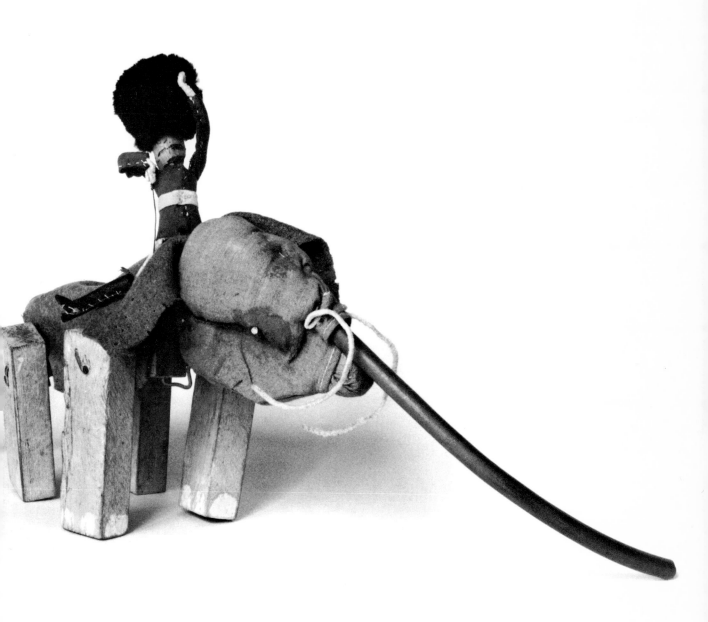

There is one of some men running with an elephant. I thought that was very good. I don't know, it may just be happenstance that I didn't fill it up, but I think it's very good that way.

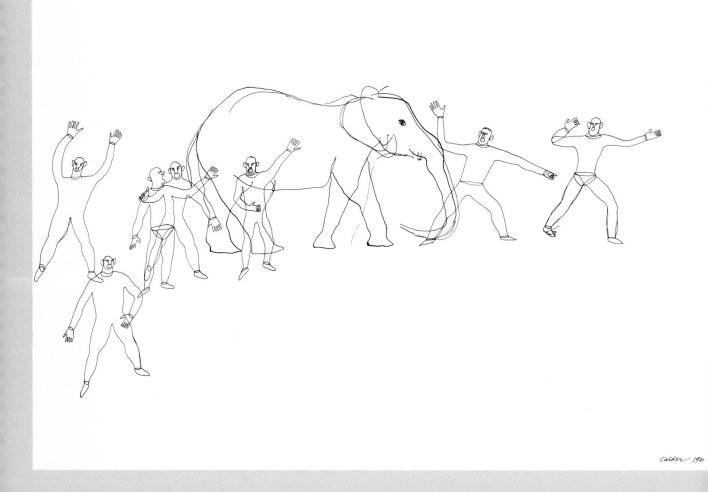

Men Persuading Elephant, 1931

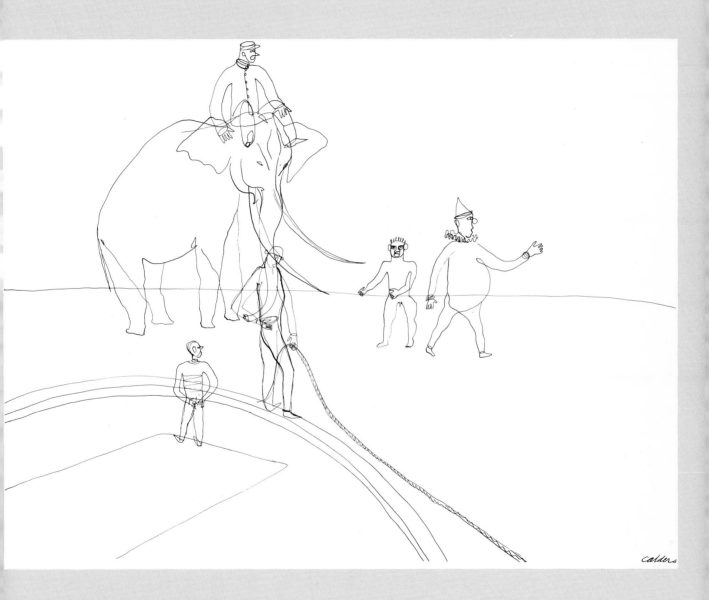

Elephant Trainer, 1931

THE ELEPHANT. The elephant has been adopted as the emblem of one of our great political parties for a number of reasons. It has a sagacious profile and a cunning eye and its loose skin and paunch suggest the clothing and figure of some of our well-known politicians of bygone days . . . Yet there is about the movements of this greatest of living mammals remarkable grace and rhythm . . . Study the elephant, if the opportunity presents itself. You will find it a fascinating subject and, perhaps, a far more beautiful one than you at first realized.

left
Elephants, 1926
right
The Lion and the Elephant (detail), 1968

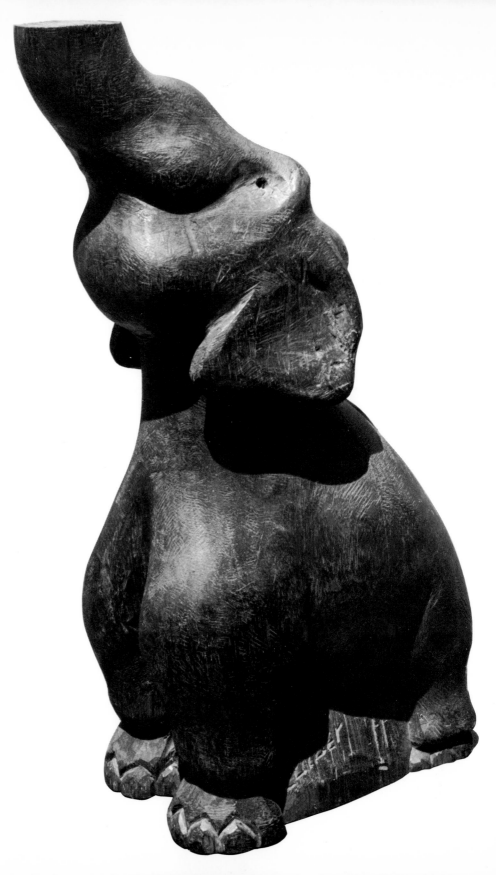

Elephant, 1928
top right
Circus Elephant (detail), 1932
bottom right
Elephant, 1944

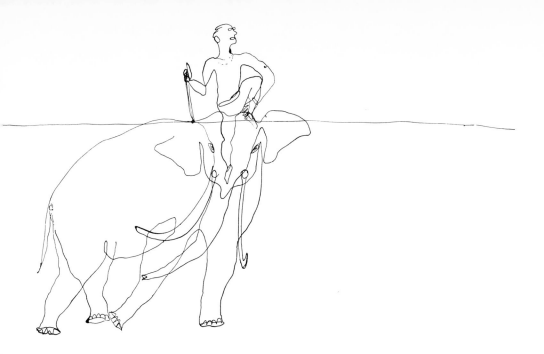
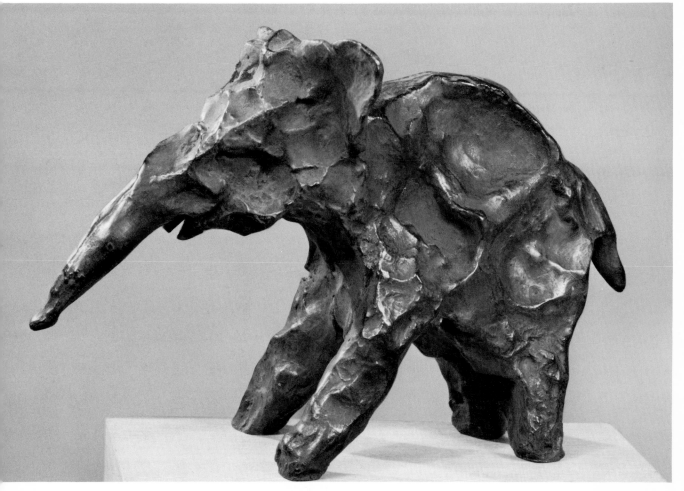

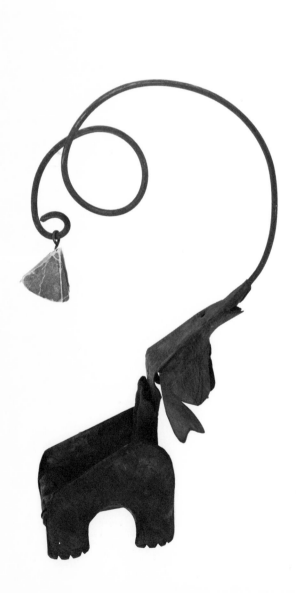

left to right
Elephant Chair with Lamp, 1928
Red Elephant with Three Black Heads, 1968
Elephant, c. 1930

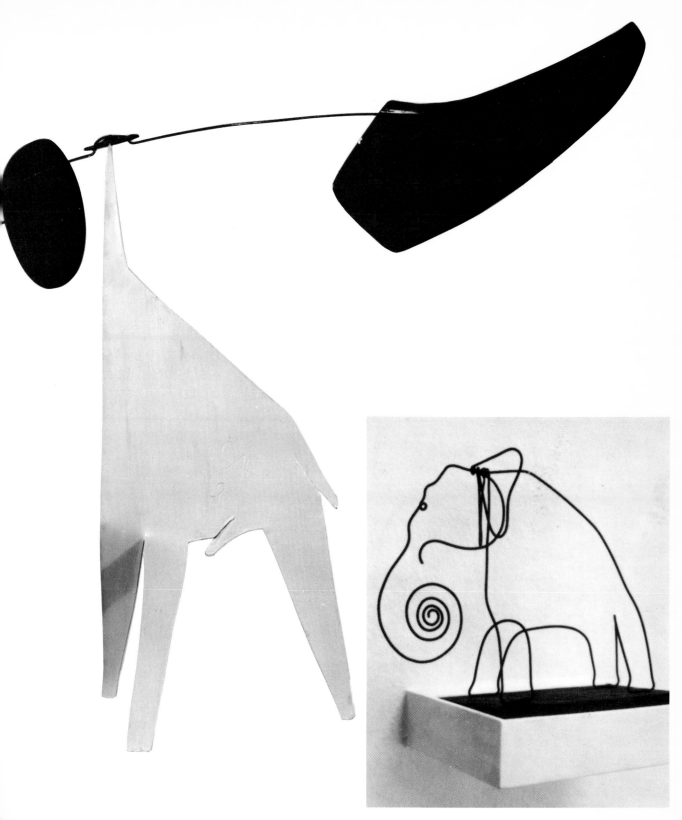

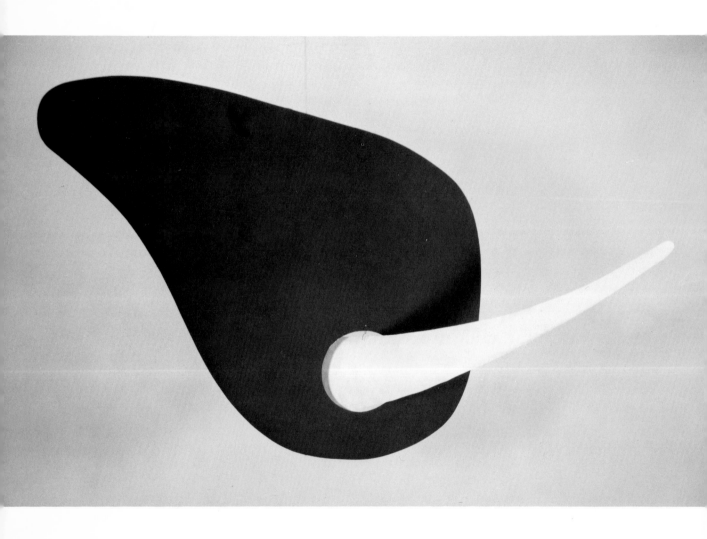

Elephant Head, c. 1939
top right
Blue Elephant with Red Ears, 1971
bottom right
Elephant, 1942

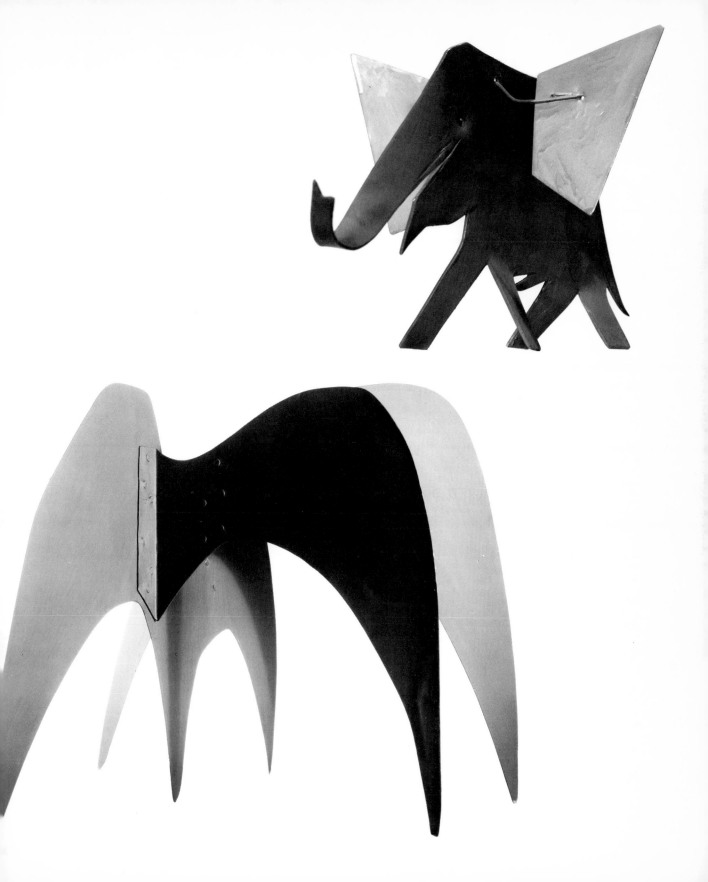

Shortly before sailing, I insisted on trying to show Sweeney how to dance and managed to fall backward. His forehead hit my Adam's apple and my voice disappeared. It was rather lugubrious. I recovered my voice later on, but have never quite managed to make the old noise of the seal in my circus.

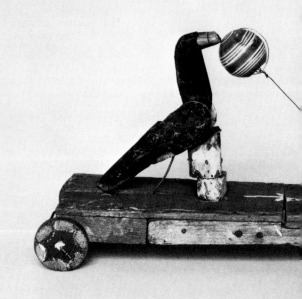

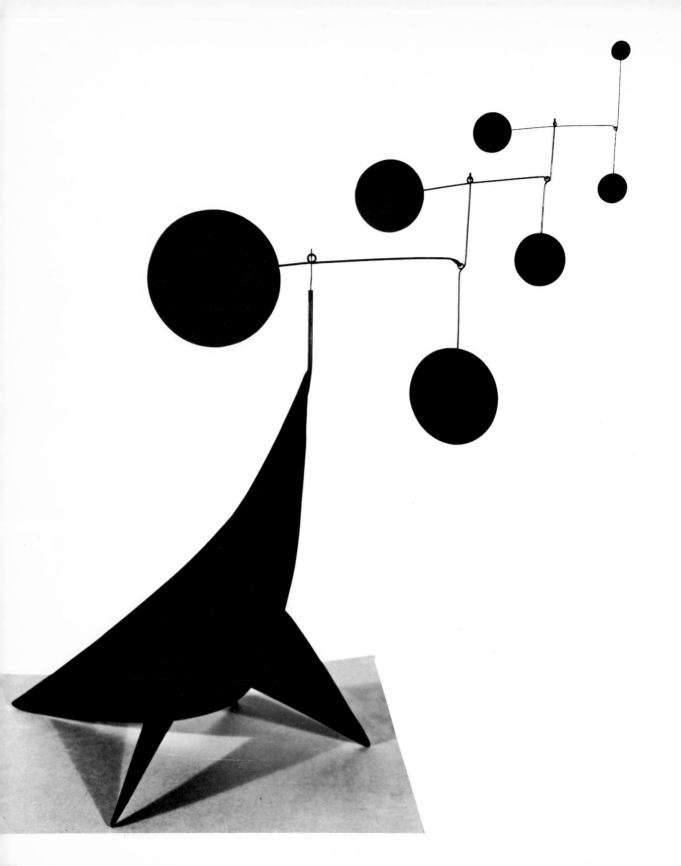

RHYTHM—SEALS. It would be hard to find a better example of consummate grace than the seal, or a more difficult model for the artist.

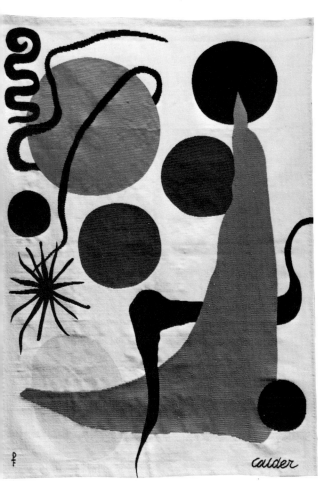

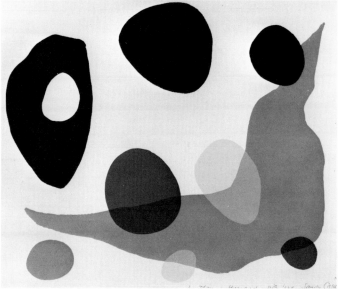

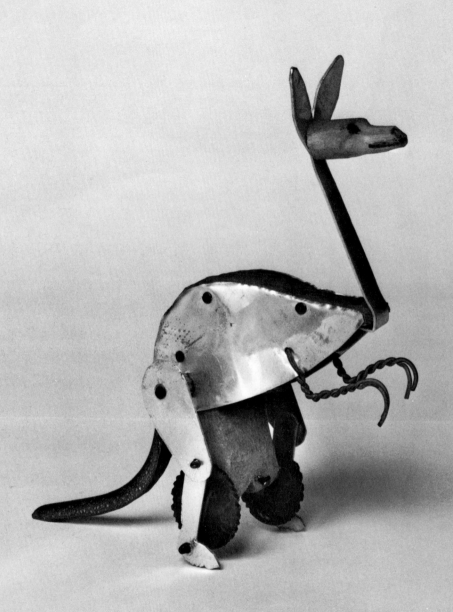

Some girls I knew introduced me to
a Serb who was in the toy business.
The Serb said that if I made some
articulated toys I could earn a
living at it, so I was interested,
because I did not have many
nickels. The base of my subsistence
was still seventy-five dollars a
month provided by mother, and my
ingenuity. I made my own
workbench, for instance, and
whatever furniture was needed,
with planks and old cases. So, I
immediately set to work and made
some articulated toys with wire,
wood, tin, and leather. When I
looked for my Serb, he had
disappeared, but I continued
making toys in this way.

Previously, I had embellished a
humpty-dumpty circus made by a
Philadelphia toy company. There
was an elephant and a mule. They
could be made to stand on their
hind quarters, front quarters, or
heads. Then there were clowns with
slots in their feet and claws in their
hands; they could balance on a
ladder on one foot or one hand.
I had once articulated these things
with strings, so the clown would
end up on the back of the elephant.

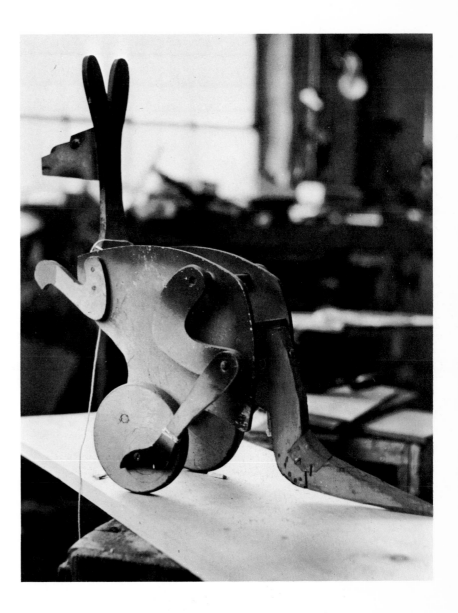

Kangaroo, 1927

143

The cow is a languid, long suffering animal.

Old Bull, 1930

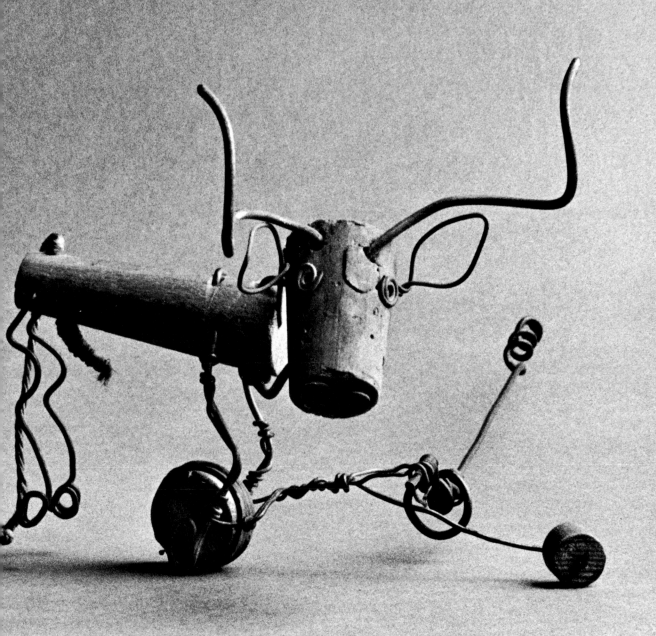

The form isn't very elegant.

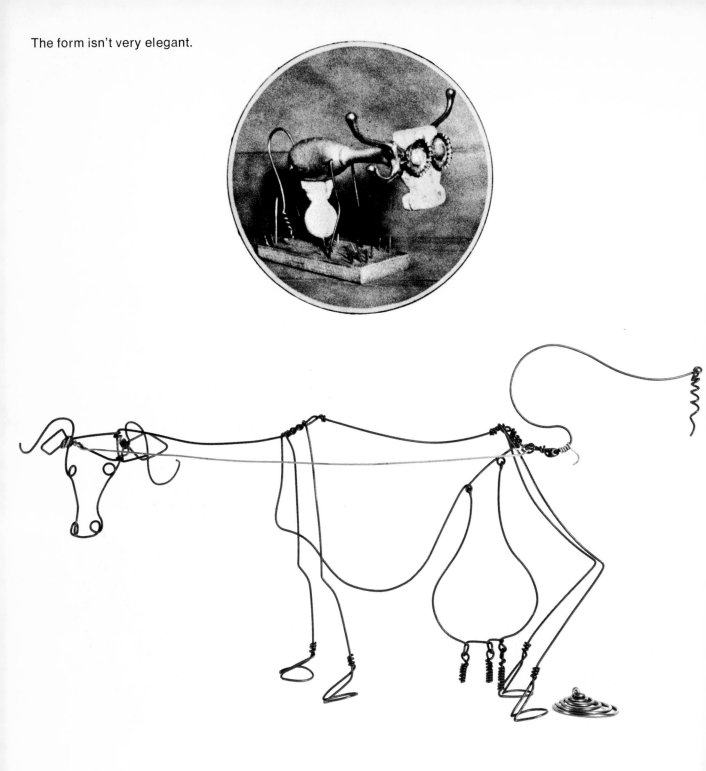

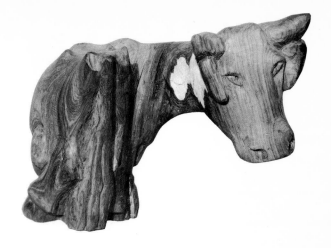

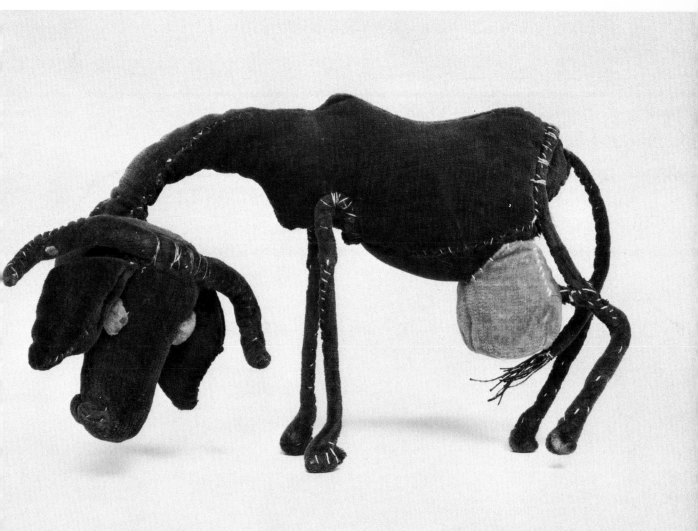

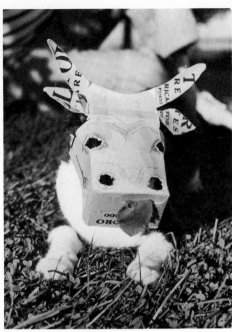

Calder's cat as a cow, 1950
bottom
Cow with Yellow Face, 1971
right
The Cow, 1970

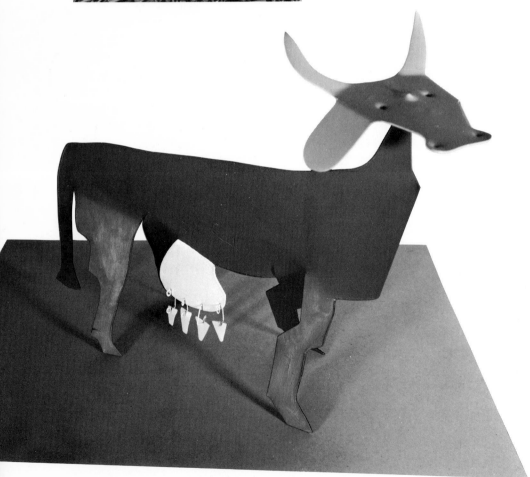

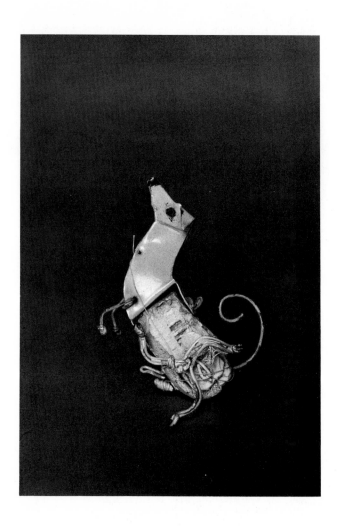

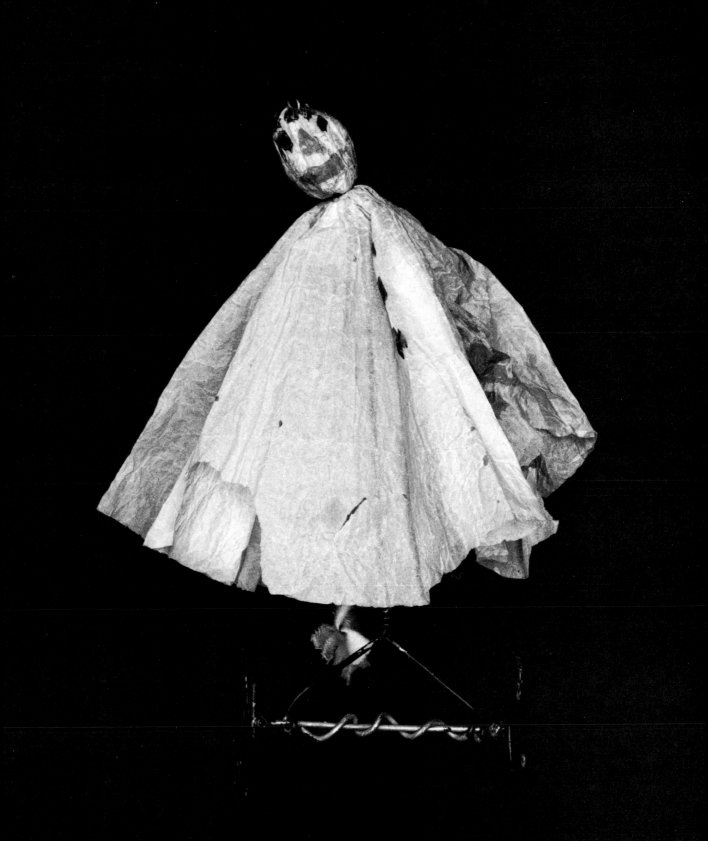

I did a few things for an American magazine called *Le Boulevardier,* it was something like *The New Yorker.* Marc Réal knew me from this; he liked the circus, brought friends, newspapermen, circus critics. And then I made a dog for Paul Fratellini.

One time Réal brought in Paul Fratellini and he took a fancy to the dog in my circus show. It was made of rubber tubing and he got me to enlarge it for his brother Albert, who always dragged a dog around with him. Before that he had had a stuffed dog. Mine trotted and its tail wagged around. However, they just ignored the fact that I had made it and never announced it in their act—it remained a gift.

Calder with Fratellini's dog, c. 1930

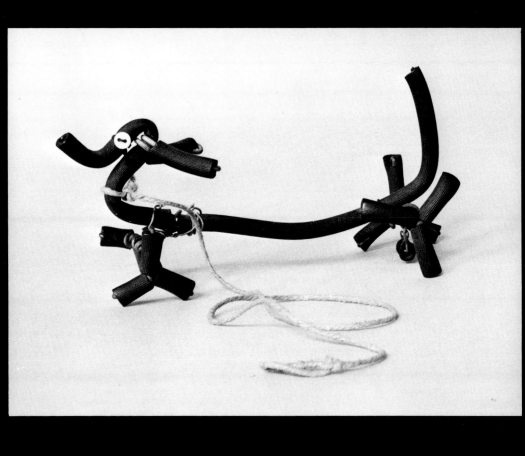

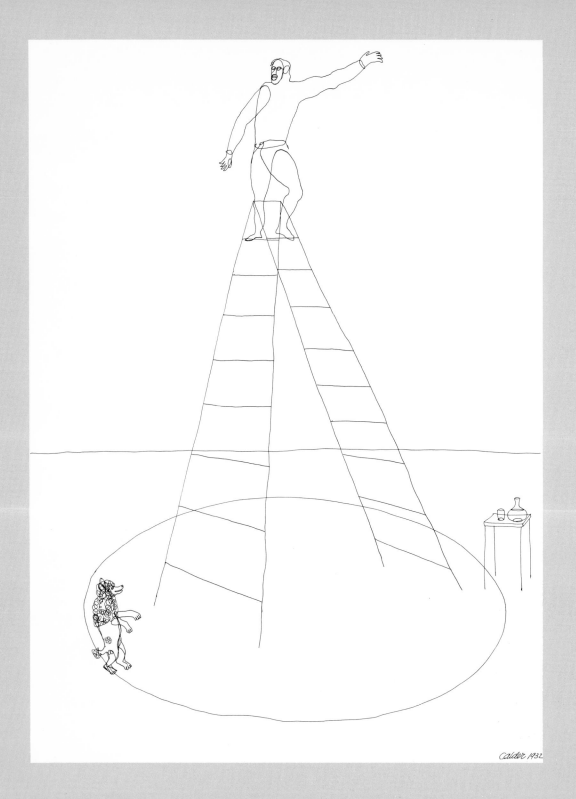

Man on Ladder, 1932

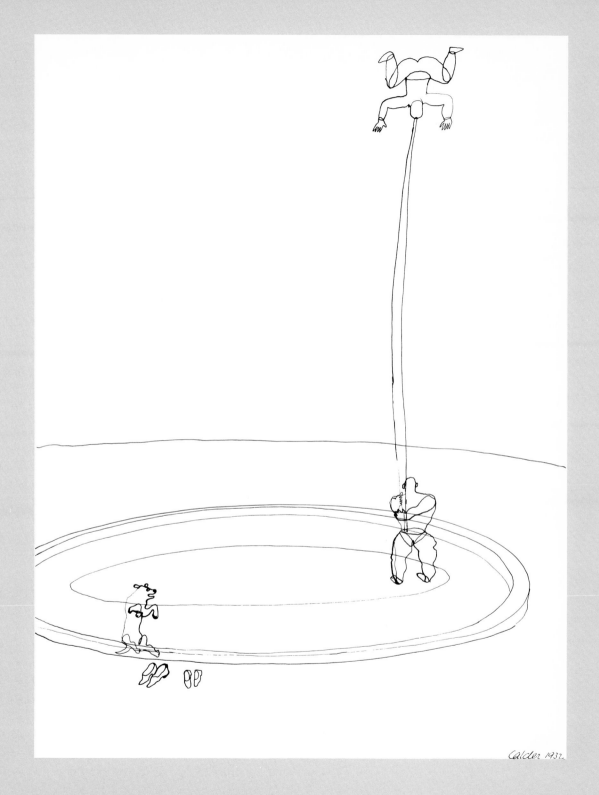

Calder 1932

Precision, 1932

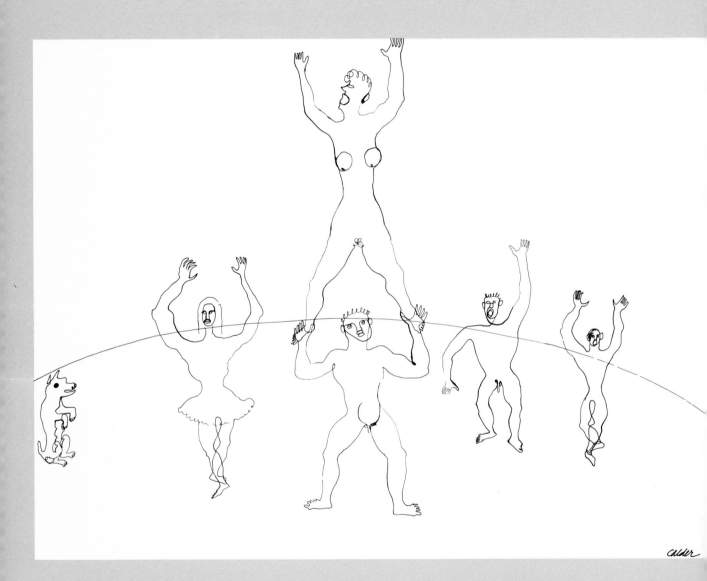

The Tumblers, 1932

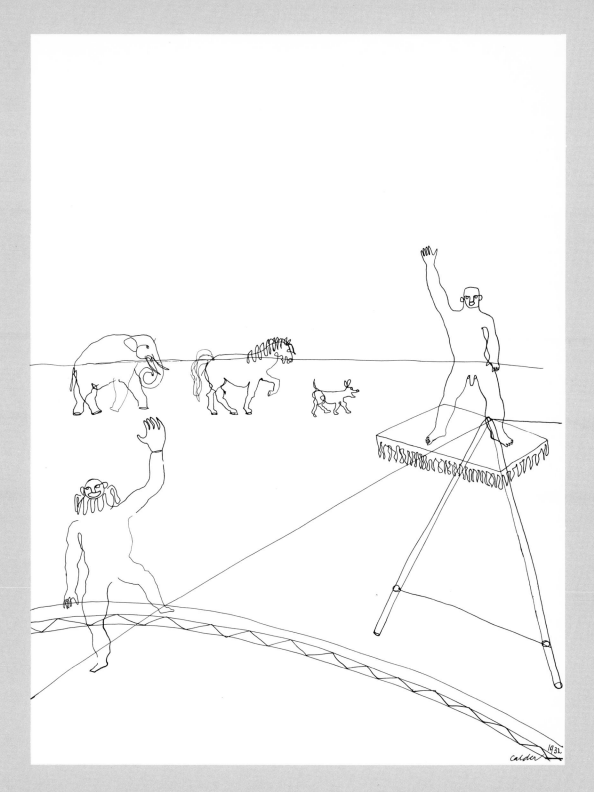

Trapeze Artists with Animals, 1932

Here, you see, are the bleachers. And this gives a sense of the bowl.

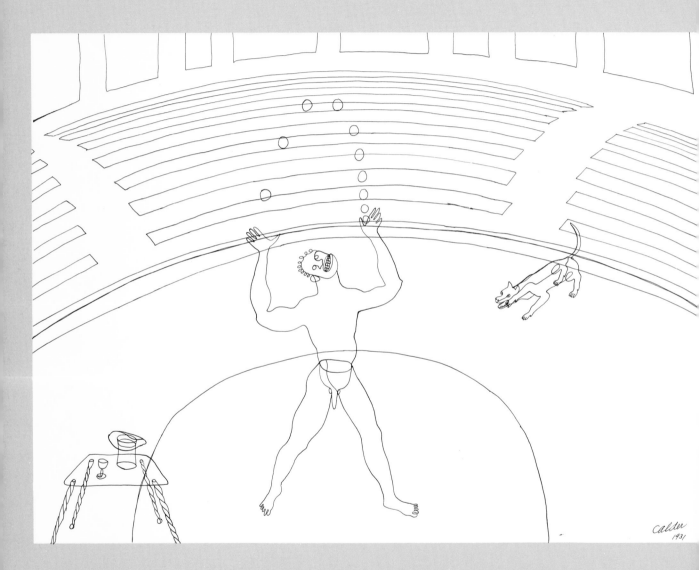

Juggler with Dog, 1931

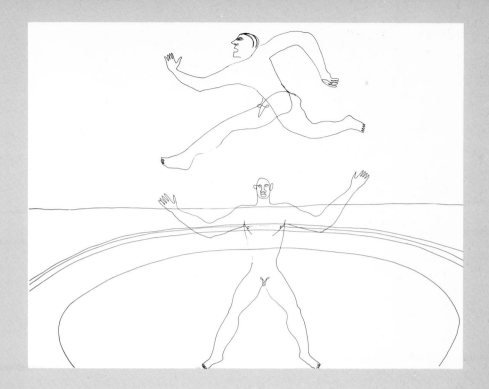

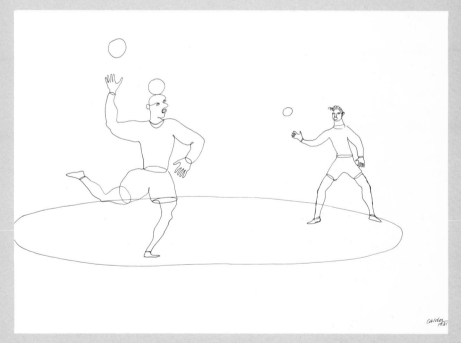

top
The Leap, 1932
bottom
Tumblers with Balls, 1931

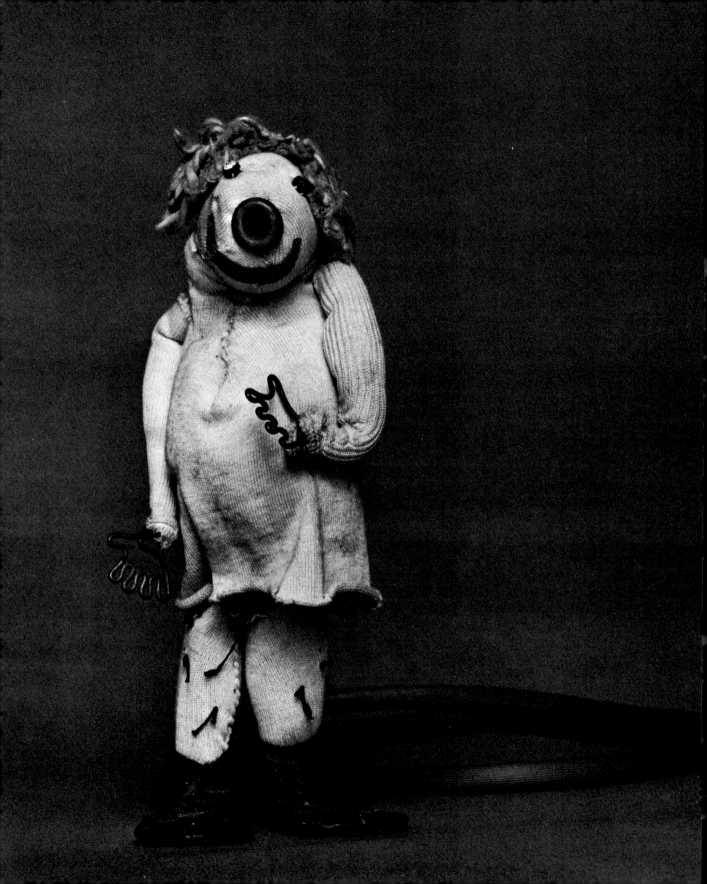

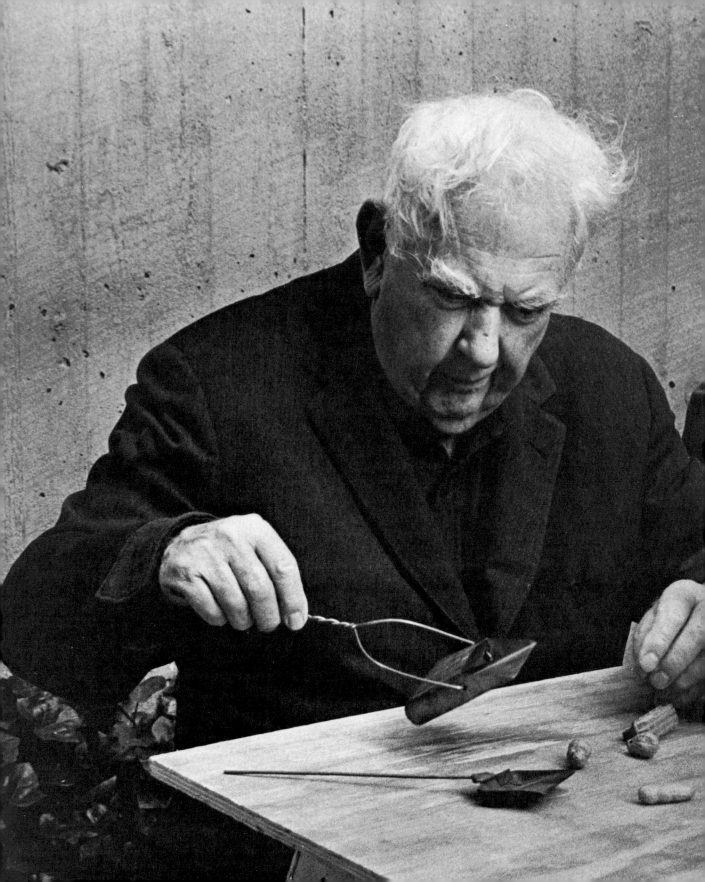

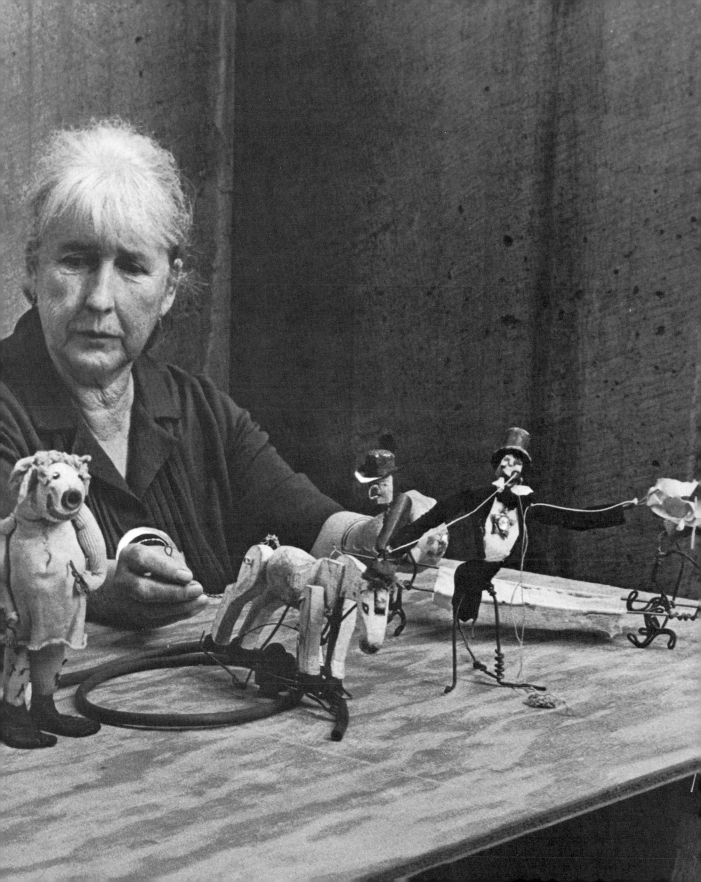

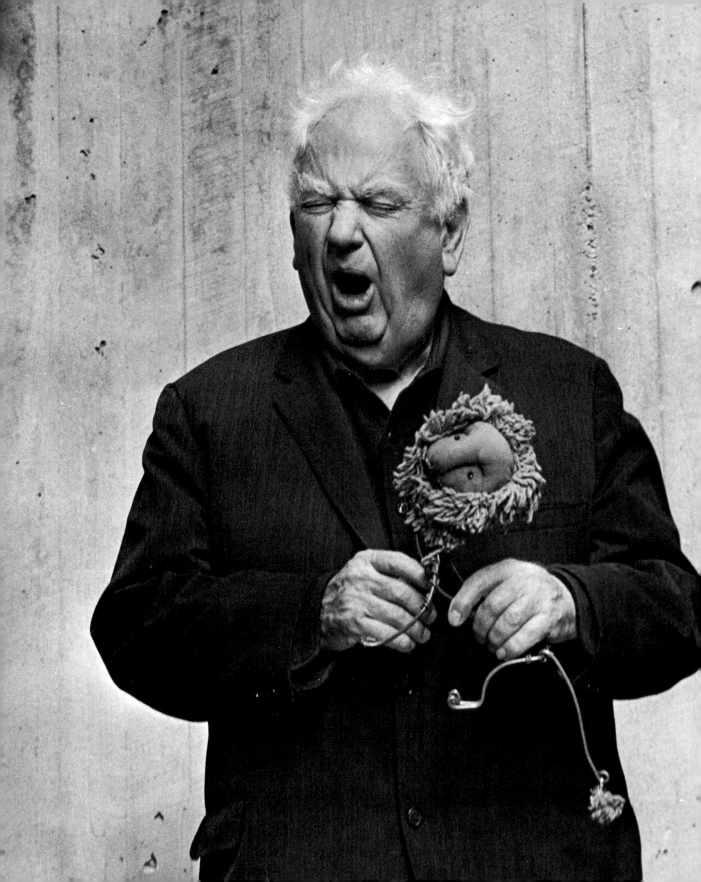

Circus-oriented Chronology

1898 Alexander Calder (known to his friends as Sandy) born July 22, Lawnton, Pa. Grandfather and father were sculptors, mother a painter.

1919 Graduated as mechanical engineer from Stevens Institute of Technology, Hoboken, N.J.

1922 Began to draw in public night school, New York, under Clinton Balmer.

1923 Studied painting, Art Students League, New York, till 1926.

1924 Worked as free-lance artist for *National Police Gazette*, New York, through 1926.

1925 Given two-week pass to cover Ringling Brothers and Barnum & Bailey Circus for *National Police Gazette*. Spent evenings sketching in menagerie tent. Did drawing of the circus for May 23, 1925, *Gazette*.

1926 Published *Animal Sketching,* based on drawings of circus animals done previous year.

Redesigned a Humpty-Dumpty circus made by a Philadelphia toy company.

Made first animated toys and first wire sculpture, *Josephine Baker,* in Paris.

Began miniature Circus in Paris.

1927 Gave first modest Circus performances in his rue Daguerre studio-room in Paris; continued to give them there through the twenties, with sculptor Isamu Noguchi usually in charge of the victrola music.

Toys exhibited at Salon des Humoristes, Paris.

Supervised manufacture of "action toys" made from his models by Gould Manufacturing Co., Oshkosh, Wis.

1928 First one-man exhibition (wire sculpture, including several circus figures) at Weyhe Gallery, New York.

A few Circus performances in his room on Charles Street, New York.

1929 Actively enlarged Circus, which then required five instead of two suitcases to transport, and gave number of expanded performances in New York, for which he made printed linoleum-cut fliers for invitations. Among the performances: in Paul Nitze's apartment; at dress designer Elizabeth Hawes's showroom; in house of Mildred Harbeck and her sister, for many guests including Frank Crowninshield, Edward Steichen, E. Weyhe; in stage designer Aline Bernstein's house, Isamu Noguchi running the victrola (this performance fictionalized by Thomas Wolfe in *You Can't Go Home Again*).

Circus performance for his parents—and neighbors—at their home in Pittsfield, Mass.

First exhibition of wood sculpture (including several circus figures) at Weyhe Gallery, New York.

First Paris exhibition of wire and wood sculpture at Galerie Billiet (including number of circus subjects).

Circus performance in his Paris studio on rue Cels; another in Japanese painter Foujita's Paris studio, Foujita providing music with victrola and drum.

A public Circus performance in Paris, in a Montparnasse hotel room, reported in *Paris Montparnasse*.

Made large model of Circus rubber-hose and wire dachshund, "Miss Tamara," for clown Albert Fratellini, who featured it in his act for years.

First wire jewelry exhibited at Neumann-Nierendorf Gallery, Berlin; a Circus performance given at the gallery.

1930 Paris Circus performances given more and more frequently, now in his Villa Brune apartment; William Einstein ran the victrola. Spectators included many leaders of Paris art world such as Mondrian, Miró, Léger, Cocteau, Kiesler, Man Ray, Pevsner, Arp, Pascin, van Doesburg, Le Corbusier, Hélion.

Circus performance at gallery of Harvard Society for Contemporary Art, Cambridge, Mass., in connection with exhibition of wire sculpture; audience included John Walker, Lincoln Kirstein, Alfred H. Barr, Jr., Edward M. M. Warburg, and group of Harvard boys.

1931 Made final Circus figures in Paris and gave performances at studio near his house on rue de la Colonie; sometimes performances given three nights in a row for as many as one hundred people.

Circus performance for composer Edgar Varèse and filmmaker Jean Painlevé.

Made numerous large pen-and-ink circus drawings in Paris, through following year.

Circus run of five nights in New York, held in vacant store at Seventh Avenue near Fifty-seventh Street. *The World* reported capacity audience of thirty persons.

Circus performance for Mrs. Edward Holten James, Calder's future mother-in-law, at her home in Concord, Mass., the night before he married Louisa James.

Circus performance for Abstraction-Création group in an exhibition tent in the 15th arondissement in Paris.

1932 Made number of small circus drawings on Cape Cod; eight of these acquired by Philadelphia Museum of Art in 1941.

First exhibition of mobiles at Galerie Vignon, Paris.

Circus performed for Joan Miró at his house in Montroig, Spain; farmers and workmen of the district were the audience.

1933 Circus performances in Barcelona and Madrid. Bought an eighteenth-century house in Roxbury, Conn., and gave Circus performances there in the 30s and 40s—attended by many artists, writers, collectors, and museum people such as Saul Steinberg, Peter Blume, Marcel Breuer, Malcolm Cowley, James Thrall Soby, A. Everett Austin.

1935 Several Circus performances in Chicago: for Renaissance Art Society and Arts Club, where he had exhibitions, others in private homes.

1936 Circus performance at James Soby's Greek Revival house in Farmington, Conn. Architect Henry Russell Hitchcock was one of many prominent guests.

1937 Circus performances in Paris for old friends, after four-year absence in the United States.

Several Circus performances in London; one large audience included Kenneth Clark, then Director of the National Gallery.

First retrospective exhibition (including number of circus subjects) at George Walter Vincent Smith Art Gallery, Springfield, Mass.

1938 Exhibition of circus and other drawings at Katharine Kuh Gallery, Chicago.

1940 Circus performance for Newbold Morris at his home in Westbury, Long Island. This was one of the few occasions on which Calder "hired out," as he puts it; the charge was one hundred dollars.

1943 Circus performance for Léger and friends in photographer Herbert Matter's New York studio; Matter recorded this in a series of photographs.

Another performance in James Johnson Sweeney's New York apartment; audience included James and Hedda Sterne, Murdock Pemberton, Malcolm Cowley.

Retrospective exhibition at Museum of Modern Art, New York; the Circus illustrated and discussed in Sweeney's catalogue introduction (revised in 1951 edition). Circus performance during the exhibition, in Museum Penthouse; among those present were Loren MacIver, Mrs. Simon Guggenheim, Dorothy C. Miller, Mr. and Mrs. Stephen C. Clark, Philip Goodwin, James Thrall Soby.

1944 Benefit Circus performance for France Forever, Washington, D.C.

Plaster models (later cast in bronze) of acrobats, animals,

etc., exhibited at Bucholz Gallery, New York.

1953 Bought house in Saché, France, and gave a number of Circus performances there in the late 50s and early 60s.

1954 Circus performance at Galerie Maeght, Calder's Paris dealer.

1958 First exhibition of large stabiles at Perls Galleries, New York.

1961 Pathé film, *Calder's Little Circus,* photographed in color by Carlos Vilardebo at Calder's home in Saché; Calder gave full performance. Victrola circus music managed as usual by his wife Louisa. Before filming was begun, a complete performance given for Vilardebo; Mr. and Mrs. Klaus G. Perls, Calder's New York dealers, attended this presentation.

1964 About one hundred large circus drawings, done 1931–32 and brought over from France at that time, found in unopened package in Calder's Roxbury studio. Feature publication of sixteen of these in *Art in America* with interview article by Cleve Gray; gouaches and crayon drawings of circus acrobats, five in each medium, made for selection for cover of the issue.

Exhibition, "Calder Circus" (the rediscovered drawings), Perls Galleries, New York.

Exhibition, "Alexander Calder—Circus Drawings, Wire Sculpture and Toys," Museum of Fine Arts, Houston, Texas.

Retrospective exhibition, Solomon R. Guggenheim Museum, New York, featured a Circus installation and group of circus drawings, with catalogue illustrations.

1967 Exhibition at Perls Galleries, New York, of rediscovered early work including circus drawings and paintings.

1969 Retrospective exhibition, Fondation Maeght, Saint-Paul, France, included installation of the Circus and catalogue photographs of Circus figures.

1970 The Circus installed by Calder at Whitney Museum of American Art, New York, on indefinite loan from the artist.

1971 Exhibition of "animobiles" at Galerie Maeght, Paris; Gimpel Fils, London; Perls Galleries, New York.

1972 On the occasion of publication of this book: exhibition of circus subjects in all media and presentation of film, *Calder's Little Circus,* at Whitney Museum of American Art, New York; and traveling American Federation of Arts exhibition of Circus photographs from this book, reproductions of sixteen circus drawings, and presentation of film, *Calder's Little Circus.*

Captions

Where sizes or dates are listed as approximate, the artist has been consulted. Dimensions: height precedes width. Figures from the Circus, photographed by Marvin Schwartz, each occupying a full page, do not have individual captions. The caption for pages 38–39 contains a complete description of the Circus.

Calder as a clown, 1950. Photo: Herbert Matter.

Circus sketches from the *National Police Gazette*, May 23, 1925.

0–13 Ringling Brothers and Barnum & Bailey Circus, Madison Square Garden, New York, 1923-24.
Photos: Circus World Museum, Baraboo, Wis.

6–17 Clippings from Calder's scrapbook describing the early performances of the Circus in Paris and New York. Archives of American Art, Smithsonian Institution, Washington, D.C.

9 Invitation to a performance of the Circus at dress designer Elizabeth Hawes's showroom in New York, August 28, 1929. Invitation to a performance of the Circus at Mildred Harbeck's house in New York, October 29, 1929.

0 A Circus performance in the Museum of Modern Art Penthouse, New York, 1943, on the occasion of the Calder retrospective. Photo: George Arnberg.

1–22 A Circus performance for Fernand Léger and friends, photographed by Herbert Matter in his New York studio in 1943.

3 Circus year in New York, 1929. Photo: André Kertesz.

5–36 Stills from the film by Carlos Vilardebo, *Calder's Little Circus*; Pathé Cinema Corporation, 1961.

8–39 The Circus, which Calder made between 1926 and 1931, as he installed it at the Whitney Museum of American Art, New York, in 1970. It consists of 55 figures and animals ranging from 7" to 14" high, as well as a miniature trapeze, lion's cage, tent, ring, and other pieces of circus equipment. The materials used for the Circus include wood, metal, cloth, paper, leather, wire, string, rubber tubing, corks, buttons, sequins, nuts and bolts, bottle caps. The photograph of Monsieur Loyal, ringmaster, appears on the preceding page and performers featured in the following pages are, in the order of their appearance: clown, 48–49; acrobats, 50, 56–58; trapeze artists, 64–65; tightrope artists, 68–69; exotic dancer with spear thrower, the Sultan of Senegambia, and stretcher bearers, 77–81; bearded lady, 82; Negress, 83–84; sword swallower, 88; Japanese wrestlers, 89; cowboys, 90–91, 93; horse, 94; Pegasus, 98; charioteers, 105; Rigoulot, the strong man, weight lifter, 109; cyclist, 112; man on stilts, 113; prima donna, 116; Fanny, the belly dancer, 117; lion, 119, 121; camel, 125; elephant and trainer, 127; seals, 139; kangaroo, 142; cows, 145, 147; dog, 150; parachutist, 151; Miss Tamara, the dachshund, 153; little clown, the trumpeter, 161.

40 Wire sign for Weyhe Gallery exhibition, 46½" high, 1928. Whitney Museum of American Art, New York.

41 *Circus*, wire, made for Cleve Gray's article in *Art in America* (see bibliography), 11" long, 1964. Collection of Howard and Jean Lipman, Wilton, Conn.

42 *Three-Ring Circus*, watercolor and ink, 19" x 24½", c. 1930. Kiko Gallery, Houston, Texas.

43 *Five-Ring Circus*, watercolor and ink, 25" x 18½", 1930. Collection of Frank W. Hoch, Irvington-on-Hudson, N.Y.

44 *The Spotlight*, gouache, 22½" x 30½", 1969. Collection of Charles Benenson, Greenwich, Conn.

45 *The Red Ring*, gouache, 29¼" x 42¼", 1970; Mrs. Joseph Schlang, New York.

46 *Circus Interior*, pen and ink, 19" x 14", 1932. Museum of Modern Art, New York.

47 *The Arena*, gouache, 29¼" x 42¼", 1966. Louise Ferrari Gallery, Houston, Texas.
Between the Acts, gouache and ink, 19" x 24¾", c. 1930. New Jersey State Museum, Trenton.

51 *Handstand*, wood, 34" high, 1928. Collection of the artist.
Acrobats, wire, about 36" high, c. 1930. Present owner unknown.
Acrobats, gouache, 29½" x 43¼", 1967. Galerie Maeght, Paris.

52 *The Handstand*, pen and ink, 22¾" x 30¾", 1931. Collection of Howard and Jean Lipman, Wilton, Conn.
Three Men High, wood, 29⅜" high, 1928. Collection of Jean and Sandra Davidson, Saché, France.
Acrobats, wood, 54" high, c. 1926. Collection of the artist.

53 *Acrobats*, bronze, 20¼" high, 1944. Fondation Maeght, Saint-Paul, France.
Acrobats (mobile sculpture in two pieces), bronze, 11" high, 1944. Perls Galleries, New York.

54 *Acrobats*, wire, 27¾" high, 1928. Collection of Mr. and Mrs. John de Menil, Houston, Texas.
Tumbling Family, pen and ink, 22¾" x 30¾", 1931. Collection of Mr. and Mrs. Alvin S. Lane, New York.

55 *The Brass Family*, brass wire, 64" high, 1927. Whitney Museum of American Art, New York.

59 *Acrobats*, two gouaches, each 15¾" x 13¾", 1964. Collection of Mr. and Mrs. Peter Lipman, Golden, Colo.

60 *Acrobat*, wire, 19¾" long, 1930. Private collection, Paris.
Handstand, bronze, 10¾" high, 1944. Perls Galleries, New York.
Acrobat, wire, 35" long, 1930–31. Collection of Jean and Sandra Davidson, Saché, France.

61 *Somersaulters*, pen and ink, 22¾" x 30¾", 1931. Collection of Mr. and Mrs. Alvin S. Lane, New York.

62 *Man on Ladder with Troupers*, pen and ink, 22¾" x 30¾", 1931. Collection of Mr. and Mrs. S. M. McAshan, Houston, Texas.
Handstand on the Table, pen and ink, 22¾" x 30¾", 1931.

Collection of Philip A. Straus, Larchmont, N.Y.
63 *Circus Scene,* wire, 48" x 44½", 1929. Collection of the artist.
66 *Woman on the Trapeze,* pen and ink, 30¾" x 22¾", 1931. Museum of Fine Arts, Boston, Mass.
67 *Will She Make It?,* gouache, 29½" x 43", 1969. Makler Gallery, Philadelphia, Pa.
The Catch, pen and ink, 22¾" x 30¾", 1931. Collection of Dr. and Mrs. Arthur E. Kohn, New York.
70 *Tightrope,* wood, metal rods, wire, and movable wire figures with lead weights, 9' 3½" long, 1937. Collection of the artist.
71 *Woman on Cord* (mobile sculpture, three pieces and base), bronze, 21" high, 1944. Perls Galleries, New York.
Study for Woman on Cord, pen and ink, 22½" x 31", 1944. Collection of Mr. and Mrs. Klaus G. Perls, New York.
72 *Tightrope Artist,* pen and ink, 9¾" x 19", 1932. Philadelphia Museum of Art, Philadelphia, Pa.
73 *Ladies on a Tightrope,* gouache, 29¼" x 43", 1967. Hokin Gallery, Palm Beach, Fla.
74 *Tightrope Artist Hanging by Her Hands,* pen and ink, 22¾" x 30¾", 1932. Collection of Mr. and Mrs. Carter Burden, New York.
On the High Wire, pen and ink, 20½" x 24⅞", 1932. Collection of Howard and Jean Lipman, Wilton, Conn.
75 *Tightrope Walker,* pen and ink, 22¾" x 30¾", 1931. Collection of Dr. Jack Fein, New York.
85 *Josephine Baker,* wire, 39" high, 1927–29. Museum of Modern Art, New York.
86 Wire kitchenware, made in the 30s, in the artist's kitchen, Roxbury, Conn. Photo: Pedro E. Guerrero.
87 *Josephine Baker,* wire, 28" high, 1926. Musée Nationale d'Art Moderne, Paris.
Jewelry, wire, c. 1940. Perls Galleries, New York.
92 *Rodeo Style,* pen and ink, 9⅛" x 18⅝", 1932. Philadelphia Museum of Art, Philadelphia, Pa.
95 *Bareback Rider,* wood, wire, and cloth, about 24" high, c. 1929. Present owner unknown.
Circus, oil, 25½" x 36", 1926–27. Collection of T. G. Galli, Plainfield, N.J.
Before the Leap, gouache, 29½" x 43", 1969. Collection of Mr. and Mrs. Edwin E. Hokin, Highland Park, Ill.
96 *The Horseback Performance,* pen and ink, 22¾" x 30¾", 1931. Perls Galleries, New York.
Three on a Horse, pen and ink, 22¾" x 30¾", 1931. Collection of Mr. and Mrs. F. M. Titelman, Altoona, Pa.
Bareback Family Group, pen and ink, 21⅞" x 30⅝", 1932. Kiko Gallery, Houston, Texas.
97 *Bareback Act,* pen and ink, 22¾" x 30¾", 1931. B. C. Holland Gallery, Chicago, Ill.

99 *Horse,* wire, 22½" high, 1928. Collection of the artist.
Equine, gouache, 29¼" x 43", 1971. Perls Galleries, New York.
100 *Horse,* walnut, 15½" high, 1928. Museum of Modern Art, New York.
Horse, wire, 11½" long, c. 1928. Collection of Mr. and Mrs. Klaus G. Perls, New York.
Horse, bronze, 8⅛" long, 1944. Joseph H. Hirshhorn Collection, Greenwich, Conn.
101 *Toy Horse,* wood and wire, 31" long, 1926–27. Collection of Howard and Jean Lipman, Wilton, Conn.
102 *Stallion,* painted sheet metal and wire, 60" high, c. 1950. Perls Galleries, New York.
103 *Horse and Rider,* painted sheet metal, 13" high, c. 1946. Collection of William K. Jacobs, Jr., New York.
106 *Ben Hur,* pen and ink, 22¾" x 30¾", 1931. Collection of Mr. and Mrs. Alvin S. Lane, New York.
107 *The Chariot,* painted sheet metal and wire, 63" long, 1961. Collection of Howard and Jean Lipman, Wilton, Conn.
108 *Weight Lifter,* bronze, 8⅝" high, 1930. Collection of Jean and Sandra Davidson, Saché, France.
110 *Weight Lifter,* crayon and ink, 19" x 24½", c. 1931. Collection of Maurice Vanderwode, Great Neck, N.Y.
Monkey and Tiger, gouache, 29" x 43", 1969. Galerie Wally Moos, Montreal, Canada.
111 *Weight Thrower,* wire, 27½" high, 1929. Musée National d'Art Moderne, Paris.
114 *Cycle Act,* pen and ink, 22¾" x 30¾", 1931. Collection of Dr. and Mrs. Seymour Adelson, Southfield, Mich.
115 *The Circus,* pen and ink, 20¼" x 29¼", 1932. Collection of Mr. and Mrs. Klaus G. Perls, New York.
118 *In the Spotlight,* pen and ink, 12" x 8½", 1932. Philadelphia Museum of Art, Philadelphia, Pa.
120 *Lion Tamer,* pen and ink, 12½" x 14", 1932. Philadelphia Museum of Art, Philadelphia, Pa.
122 *The Wild Beast Cage,* pen and ink, 21¾" x 20⅝", 1932. Collection of Howard and Jean Lipman, Wilton, Conn.
123 *Through the Hoop,* pen and ink, 22½" x 30½", 1932. Collection of Mr. and Mrs. Robert M. Meltzer, Great Neck, N.Y.
Lion's Leap, ink and colored crayon, 19⅝" x 25½", 1931. Collection of Mr. and Mrs. Dixon Stroud, West Grove, Pa.
128 *Men Persuading Elephant,* pen and ink, 22¾" x 30¾", 1931. Collection of Jean and Sandra Davidson, Saché, France.
129 *Elephant Trainer,* pen and ink, 22¾" x 30¾", 1931. Collection of Mrs. Alexander Calder, Saché, France.
130 *Elephant,* pen and ink, 5¾" long, 1926. From Calder, *Animal Sketching,* p. 62.
Elephant, pen and ink, 3½" high, 1926. From Calder, *Animal Sketching,* p. 20.

31 *The Lion and the Elephant,* gouache, 22¼" x 30¼", 1968. Collection of Mr. and Mrs. Miner Keeler, Grand Rapids, Mich.

32 *Elephant,* wood, 16" high, 1928. Collection of the artist.

33 *Circus Elephant,* pen and ink, 22¾" x 30¾", 1932. Collection of Mrs. Adolph I. Susholtz, Houston, Texas.

Elephant, bronze, 5¾" high, 1944. Collection Fondation Maeght, Saint-Paul, France.

34 *Elephant Chair with Lamp,* sheet metal, wire, cloth, paper, ⅞" high, 1928. Museum of Modern Art, New York.

35 *Red Elephant with Three Black Heads,* painted sheet metal and wire, 29⅛" high, 1968. Collection of Norman Granz, Geneva.

Elephant, wire, about 10" high, c. 1930. Present owner unknown.

36 *Elephant Head,* painted sheet metal and wire, 30" high, . 1939. Perls Galleries, New York.

37 *Blue Elephant with Red Ears* (animobile), painted sheet metal, 7½" high, 1971. Galerie Maeght, Paris.

Elephant, painted sheet metal, 20½" high, 1942. American Society of Magazine Editors, New York.

40 *Performing Seal,* painted sheet metal and wire, 33" high, . 1950. Collection of Mr. and Mrs. Leonard Horwich, Chicago, Ill.

41 *Green Ball,* Aubusson tapestry, 85" x 54½", 1971. Art Vivant Inc., New Rochelle, N.Y.

Untitled lithograph, 17½" x 22", 1962. Collection of Howard and Jean Lipman, Wilton, Conn.

43 *Kangaroo,* wood, 12" high, 1927. Action toy made for Gould Manufacturing Co., Oshkosh, Wis.

44 *Old Bull,* sheet brass, 9" high, 1930. Whitney Museum of American Art, New York.

46 *Woolworth Cow,* doorstop, darning egg, clothing hooks, cork, bottle caps, about 8" long, 1926. Present owner unknown.

Cow, wire, 6½" high, 1929. Museum of Modern Art, New York.

147 *Cow,* wood, 12⅝" high, 1928. Collection of Mr. and Mrs. George D. Pratt, Jr., Bridgewater, Conn.

148 Calder's cat as a cow, 1950. Photo: Herbert Matter.

Cow with Yellow Face (animobile), painted sheet metal and wire, 23" high, 1971. Perls Galleries, New York.

149 *The Cow,* painted sheet metal, 158" long, 1970. Collection of Mr. and Mrs. Rudolph B. Schulhof, Great Neck, N.Y.

152 Calder, about 1929, with Albert Fratellini's mobile dog. Photo: André Kertesz.

154 *Man on Ladder,* pen and ink, 30" x 22", 1932. Collection of Jean and Sandra Davidson, Saché, France.

155 *Precision,* pen and ink, 16½" x 13⅛", 1932. Philadelphia Museum of Art, Philadelphia, Pa.

156 *The Tumblers,* pen and ink, 22¾" x 30¾", 1932. Dayton's Gallery 12, Minneapolis, Minn.

157 *Trapeze Artists with Animals,* pen and ink, 25½" x 19⅝", 1932. Collection of Mrs. Alexander Calder, Saché, France.

158 *Juggler with Dog,* pen and ink, 22¾" x 30¾", 1931. Collection of Howard and Jean Lipman, Wilton, Conn.

159 *The Leap,* pen and ink, 22¾" x 30¾", 1932. Collection of Mr. and Mrs. Leonard Horwich, Chicago, Ill.

Tumblers with Balls, pen and ink, 22¾" x 30¾", 1931. Collection of Jean and Sandra Davidson, Saché, France.

161 *Tumbler on Swing,* pen and ink, 30¾" x 22¾", 1931. Collection of Howard and Jean Lipman, Wilton, Conn.

162–64 Alexander and Louisa Calder with some of their favorite members of the Circus troupe, photographed by Marvin Schwartz at the Whitney Museum of American Art, New York, just before this book went to press.

Selected Bibliography

Archives of American Art, Smithsonian Institution, Washington, D.C. *Papers.* 1 microfilm roll.
A collection of Calder's papers that contains press clippings, exhibition catalogues and notices, Circus invitations, and photographs. Calder's scrapbook, included in this collection, contains the newspaper articles relating to the early Circus performances that are reproduced in this book.

Arnason, H. H. *Calder.* Princeton, N.J.: D. Van Nostrand Company, Inc., 1966.
Text includes a chapter on "The Circus Years," with photos by Pedro E. Guerrero of Circus figures and related wood and wire toys.

Bellew, Peter. *Calder.* Barcelona: Ediciones Poligrafa, S.A., 1969. Photographs by Clovis Prevost juxtapose actual circus acts with Calder sculpture.

Calder, Alexander. *Animal Sketching.* Pelham, N.Y.: Bridgman Publishers, 1926.
Sixty-two pages of pen-and-ink sketches accompanied by brief comments. This book was published the year after Calder spent several weeks sketching in the menagerie tent at the Ringling Brothers and Barnum & Bailey Circus, which he covered for the *National Police Gazette.*

Calder, Alexander. *An Autobiography with Pictures.* New York: Pantheon Books (Random House), 1966.
Calder's autobiography, recorded by his son-in-law Jean Davidson, in which he recounts the development of the Circus, and describes some of the early performances in Paris and later ones in New York.

Fondation Maeght. *Calder* (exhibition catalogue). Paris, 1969.
Major retrospective exhibition which included an installation of the entire Circus. The catalogue has an introduction, in French, by James Johnson Sweeney and photographs of individual Circus figures as well as the whole Circus.

Gray, Cleve. "Calder's Circus." *Art in America,* Vol. 52, No. Five (October 1964), pp. 22–48.
Portfolio of sixteen circus drawings made in 1931 and 1932 (reprinted as a boxed portfolio); interview with Calder about his interest in the circus theme; letter from Miró describing a performance of the Circus at his home in Montroig, Spain.

Houston, Texas. Museum of Fine Arts. *Alexander Calder. Circus Drawings, Wire Sculpture and Toys* (exhibition catalogue). Houston, 1964.
Introduction discusses evolution of the Circus.

Kuh, Katharine. *The Artist's Voice. Talks with seventeen artists.* New York: Harper & Row, 1962.
Interview with Calder with a brief mention of the Circus and a photograph of the Circus ring with acrobats.

Mulas, Ugo. *Calder* (introduction by H. Harvard Arnason). New York: Viking Press, 1971.
Photographs by Ugo Mulas of Circus figures, circus drawings, and related wire figures. Comments by Calder about the Circus in the introduction.

New York. Museum of Modern Art. *Alexander Calder* (text by James Johnson Sweeney). 1943. Reprinted, with revisions, 1951.
Introduction includes a detailed section on the early years of the Circus, with photographs. Writing in 1943, Sweeney was the first to appraise the importance of the Circus in the development of Calder's later style.

New York. Museum of Modern Art. *A Salute to Alexander Calder* (introductory essay by Bernice Rose). 1969.
Several mentions of the Circus and a quotation from Thomas Wolfe's fictional description of a performance in *You Can't Go Home Again.*

Osborn, Robert. "Calder's International Monuments," *Art in America,* Vol. 57, No. Two (March–April 1969), pp. 32–49.
Monumental sculptures reproduced and discussed with the artist include the stabile titled *Monsieur Loyal.* (Monsieur Loyal is the Circus ringmaster.)

Rodman, Selden. *Conversations with Artists* ("Alexander Calder," pp. 136–142). New York: Devin-Adair, 1957.
Discussion of the artist, his background, his approach to art— with emphasis on *fun* as a basic ingredient of his style.

Solomon R. Guggenheim Museum. *Alexander Calder: a retrospective exhibition.* New York: Solomon R. Guggenheim Foundation, 1964.
The entire Circus was shown at this exhibition; catalogue includes a brief description and photographs of individual Circus figures as well as related wire figures, circus drawings, and toys.

Sweeney, James Johnson. "Alexander Calder: Work and Play," *Art in America,* Vol. 44, No. Four (Winter, 1956/57), pp. 8–13. Reprinted with different illustrations in *Art in America,* Vol. 51, No. Four (1963), pp. 92–98, and in *What Is American in American Art* (Jean Lipman, ed.), New York: McGraw-Hill, 1963, pp. 87–93. Sweeney comments on the continuity of the essentials of Calder's style, from the Circus years on.

Acknowledgments

Wolfe, Thomas. *You Can't Go Home Again.* New York: Harper & Brothers, 1934.
Chapter 18, Book 1, is a fictional description of Calder's performance of the Circus at Aline Bernstein's house in New York. See *An Autobiography with Pictures* for Calder's own description of the same performance.

Unlimited thanks to Mr. and Mrs. Klaus G. Perls of the Perls Galleries, Calder's New York dealers, who cooperated from the first planning stage of this publication—not only making their entire photo and data files available, but cheerfully answering countless queries. Similar thanks to Daniel Lelong of Galerie Maeght, Calder's Paris dealer, and to Jean Davidson, Calder's son-in-law, who collaborated in the basic source-book, *An Autobiography with Pictures.* Most of all to our great subject, Alexander Calder, who helped in every possible way.

Calder Scrapbook. The Archives of American Art (see Bibliography).

Calder Quotations. (See Bibliography for detailed titles of publications.) Pages 94, 118, 130, 141, 144 from Calder, *Animal Sketching;* pages 8, 14, 15, 18, 20, 22, 24, 53, 85, 138, 143, 152 from Calder, *Autobiography;* pages 14, 42, 45, 46, 66, 76, 97, 126, 128, 158 from Gray, "Calder's Circus"; page 8 from Kuh, *The Artist's Voice;* page 146 from Museum of Modern Art, *A Salute to Alexander Calder;* page 124 from Rodman, *Conversations with Artists.*

Photographs. Pages 25–36 by permission of the Pathé Cinema Corporation; photographs of Calder's work: Perls Galleries, New York; Galerie Maeght, Paris; and various private and public owners; for others, the photographers are credited in the captions. Photos on pages 23, 135 *(right),* 143, 152, from Calder, *An Autobiography with Pictures.*

Chronology. For help in recording details about Circus performances: besides Alexander and Louisa Calder—Alfred H. Barr, Jr., Margaret Calder Hayes, Russell Lynes, Herbert Matter, Dorothy C. Miller, George L. K. Morris, Isamu Noguchi, Daniel Catton Rich, James Thrall Soby, James Johnson Sweeney, Edward M. M. Warburg. The entire Chronology is primarily indebted to Calder, *An Autobiography with Pictures.*